AFTER HIROSHIMA
ヒロシマ・そのあと

elin o'Hara slavick
エリン・オハラ・スラヴィック

Editors: Taj Forer and Michael Itkoff
Design: Ursula Damm/dammsavage.com
Copyediting: Sally Robertson
Translation: Kyoko Selden

ISBN 978-0-9832316-5-3

Printed in China

Daylight Books
E-mail: info@daylightbooks.org
Web: www.daylightbooks.org

For my parents Ursula and William Slavick
who first taught me about Hiroshima;

最初にヒロシマについて教えを授けた
父母ウルスラおよびウィリアム・スラヴィックに

For my children Guthrie and Harper Ursula
who kissed A-Bombed trees in Hiroshima and said *sorry*;

被爆した木にキスをしてごめんねと言った
子供たちガスリーとハーパー・ウルスラに

And for the people of Japan who work for peace and
the abolition of nuclear power and weapons.

平和と核力核兵器廃絶のため
努力している日本の人々に

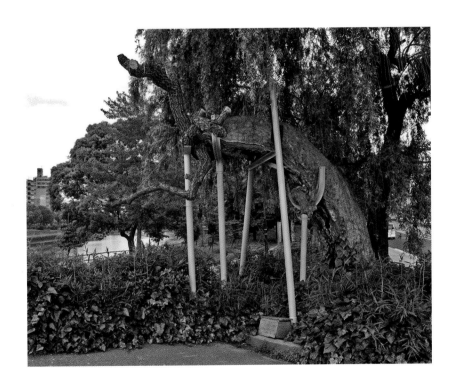

A-bombed Weeping Willow Tree, Hiroshima, Japan
被爆した広島の枝垂れ柳

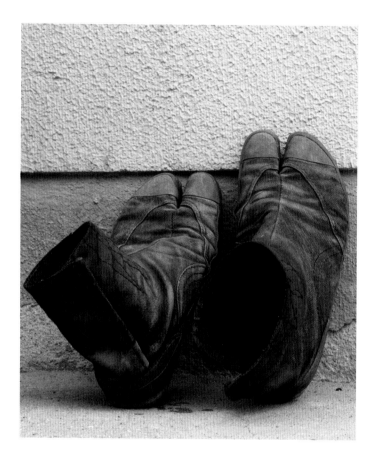

DO WALK QUIETLY

Mizuno Jun'ichi

Now so many new modern buildings stand—
this whole town by the river
was long ago
one large graveyard

Now so many cars run along this road—
beneath it
a son remains crouched
all day long
pierced by the memory of having to burn his mother
who had died swarming with maggots

Such being the case
you who now walk through Hiroshima
please do always walk quietly
with empathy

In the hospital
people with awful burns
still lie in bed

Even now suddenly, somewhere
someone with crooked fingers and a deformed face
or someone who always hid under black hair
the uncanny keloid scars on her cheek
may be dying

Such being the case
you who come to Hiroshima
when you walk through this town
please do always
walk quietly
with care…

I beg you…

今は　新しげな建物のえっと見える
この川辺りの町全部が
昔は
大けい一つの墓場でしたけん

今は車のえっと走っとる
この道の下で
ウジ虫の湧いて死んで行った
母を焼いた思い出につき刺されて
息子がひていじゅう
つくなんで　おりますけん

ほいじゃけん
今　広島を歩く人々よ
どうぞ　いついき静かあに
こころして歩いて　つかあさい

それにまだ病院にゃあ
えっと火傷を負うた人も
寝とってじゃし

今も急にどっかで
指のいがんだ　ふうのわりい人や
黒髪で　いなげな頰のひきつりを
かくしとった人が
死んで行きよるかもしれんのじゃけん

ほいじゃけん
広島に来んさる人々よ
この町を歩くときにゃあ
どうぞ　いついき静かあに
こころして
歩いて行ってつかあさいや……

のう……

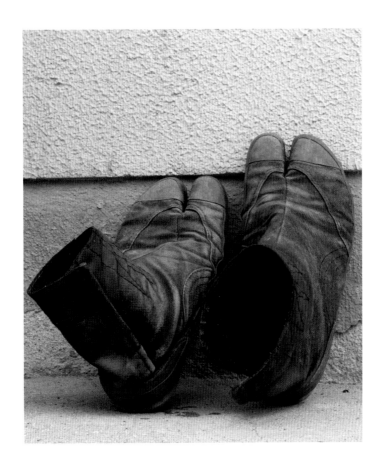

静かに歩いてつかあさい

水野潤一

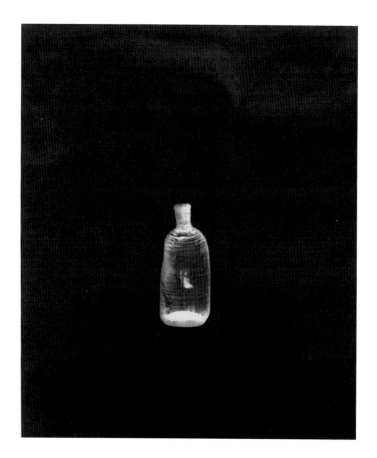

ON AN IMAGE OF A BOTTLE

James Elkins

Writing an essay for elin slavick means several things to me. First, elin was once upon a time a student of mine, and we have stayed in touch over the years. I have always liked the way her obsessions are visual, her visual sense is ethical, and her ethical concerns are pleasures: her work is a wonderful knot. So when she asked me, I thought it would be a great opportunity to try to repay a friendship with some thoughts about beauty, time, and pain.

Second, writing an essay for an artist is an exception to my usual habits. I have only written, I think, four essays for artists, including a long one for Vik Muñiz that, as far as I can see, ruined my relationship with him and has never been read. I think that in general, essays for artist's books are seldom consulted: they contribute less to the ongoing conversations about contemporary art than to the ephemeral concerns of the artist and her gallery. But this time it is different, I hope, because elin's concerns are emergent in a number of photographic practices.

Third, this is an occasion to contribute to a stream of writing on art that isn't restricted by the common forms of essay writing. I am thinking of elin's own writing, and also books by her friend Carol Mavor (who taught briefly at the School of the Art Institute of Chicago, where elin was my student). Carol's books circle around and tunnel under art historical habits, in the name of an evolving sense of voice and personal commitment—in other words, she takes the lessons about *écriture*, writing, and truth that every academic has learned from Barthes, and actually puts them to work instead of just writing scholarly analyses of them.

Fourth, this essay is an opportunity to broach some very large, in fact nearly cosmic ideas, the sort that cannot usually be opened in academia unless you're writing a 900-page dissertation or assembling your late-career magnum opus. I think there are a few things that can be usefully said about the ethics of beauty, the representations of time and pain in the context of elin's art. Perhaps this confluence of an obligation due to a friend and the opportunity of writing freely will lend just the right amount of warmth to my abstract topic.

I begin with some facts, as a scientist might see them. And then I'll move into a version of those facts, as an artist, critic, theorist, historian, or philosopher of art might see them. My purpose will be to show that these images have a particular structure of representation—a specific and complicated relation to the original event they represent—and that current photography theory does not do that complexity justice.

After that I will spend a few pages on a second subject: ethics and its relation to beauty in the representation of pain. Is it ethical to represent an event like Hiroshima with an image that is so simple, so beautiful, so decorative? This isn't an easy question for anyone whose work impinges on events of real historical significance, and I think elin's work is on the right track if art is going to continue addressing events like Hiroshima. I will conclude with a single sentence that I hope can tie the first subject—the technical details of these images—to the second subject—the ethical problems of representing this particular past.

I'll use the image that elin called, in one of her emails, LoneBlueBottle. (The name is poetic and yet technical, with the words pushed together for the filename.)

THE FOUR SHADOWS

To my eye, what makes this image immediately arresting is that it is a dim, bluish remnant of one of the most intense fluxes of light that people have ever produced. elin's images are shadowy, but they recall brilliance.

Let me put this more quantitatively. My claim is that the images in this book are shadows of shadows of shadows of shadows.

Each shadow was produced by a different light.

(Permit me a little scientific jargon. If you can, read through this. Think of it as conceptual poetry that uses science, like Christian Bök's delicate little book *Crystallography*.)

1. The first shadows were cast by the objects preserved in the museum in Hiroshima when they were struck by the radiation of the atomic explosion. The light that cast those shadows included eight kinds of radiation:

i Infrared, microwave, and radio waves, all long-wavelength photons. They would have caused the heat that started to melt the bottle. Together they are usually called "thermal radiation."

ii Visible-wavelength light. It would have been blinding.

iii Ultraviolet light. Like the first two, this is comprised of photons. Its intensity would also have been blinding.

iv Alpha rays, which are helium nuclei. These were produced by the decay of plutonium, uranium, radon, and radium. The water in this bottle—if it had water—would have stopped the α rays, casting a shadow.

v Beta rays, which are electrons. These are produced by the decay of carbon, phosphorus-32, strontium-90, and tritium. The β rays would also have been stopped by liquid in this bottle, casting a shadow.

vi Gamma rays, which are photons. These are produced by decay of cobalt-60 and cesium-137. They would have passed right through the bottle, casting no shadow.

vii X-rays, which are also photons. The higher energy x-rays would have passed through the bottle; the lower energy x-rays would have been partly absorbed, possibly casting a shadow like the one in the image.

viii Neutrons, which are baryons (in turn a kind of hadron). They are produced by the fission of uranium and plutonium. They would have passed through the bottle without interacting with it.

Together the α rays, β rays, γ rays, and, indirectly, the neutrons are called "ionizing radiation," and are responsible for much of the radiation sickness that followed the explosion. But that is not elin's subject. The object in this case is only glass.

I have already made several errors. I should not have said that the visible-wavelength light and ultraviolet light would have been blinding, because a person near that bottle would have been instantly incinerated. I should not have said that the α rays, β rays, and γ rays cast shadows, because they are not visible to the human eye, and because any eye in the area of the bottle would have been incinerated.

After the explosion, "death shadows" of people, machinery, railings, ladders, and plants were sometimes visible. Those were caused by burning or bleaching of the surfaces around the objects. The principal cause was "thermal radiation," heat from infrared, visible-wavelength, and ultraviolet light. Most light of those wavelengths was generated over a short period, one to three seconds, which prevented evaporative cooling. Near ground zero—directly underneath the place in the air where the bomb exploded—the thermal radiation exceeded 125 Joules per square centimeter, enough to burn everything flammable, causing shadows around inflammable objects. But there is no record that this particular bottle cast such a shadow.

This bottle probably did not cast a "death shadow," and if it did, there is no record of it. And at the time, there were no eyes to see the other kinds of shadows this bottle may have cast. In order for x-rays to make a shadow that looks "like

the one in the image," as I wrote, the bottle would have had to have been lying on x-ray sensitive film.

The first shadow cast by the bottle was therefore not visible, several times over: no "death shadow" is recorded; the other shadows were cast by particles and photons outside the capacity of the human eye; and any eye near enough to see this bottle would have been incinerated.

2. A second set of shadows was cast by the objects preserved in the museum in Hiroshima when elin put them out in the sun, on cyanotype paper. LoneBlueBottle is a shadow. The light that cast that shadow included the same eight kinds of radiation, but in very different intensities and proportions. The only radiation that was registered by the paper was:

 iii Ultraviolet light, which reduced the iron in the paper from iron(III) to iron(II)—that is, ferric oxide to iron monoxide. The result, after intermediate steps, is known to painters as Prussian blue, $Fe_7(CN)_{18}$.

The light that cast this shadow was not itself visible; therefore there was no shadow at the time. Or to be precise: the shadow elin might have seen when she prepared the cyanotype was not the shadow that was recorded on the cyanotype.

The cyanotype documents a shadow that was never visible, and that shadow recalls a shadow that was never visible.

3. The third shadow was cast when elin photographed this cyanotype for this book. She used a large format camera, and the third shadows were cast on a 4-inch by 5 inch negative. The light on the copy stand was, I imagine,

 ii Visible-wavelength light, color balanced to approximately 4800K, which is a standard color temperature for color negative film.

This shadow would have been visible, but elin would not have seen it, because photographers don't look at negatives when they are being exposed. She could have seen the negative once it was developed. That would have been a shadow of the cyanotype shadow.

4. Then the 4 x 5 image was scanned to make a digital master for this book. A flatbed scanner read the 4 x 5 negative or the 4 x 5 color transparency. Scanner light is usually also:

 ii Visible-wavelength light, color balanced to one of several temperatures (5600K, 4200K, 3200K).

This, too, would not have been seen. A transparency in a scanner is covered.

5. These shadows of shadows of shadows of shadows— these pictures, in this book—also cause shadows on your retinas as you turn the pages. Those faint, curved shadows are also not visible to you: as Descartes first pointed out, we do not see the shadows in our eyes. We aren't aware of what they look like. We are only aware that they exist. I have seen shadows in a person's eyes, looking through an ophthalmologist's slit-lamp microscope. It is an astonishing experience, but it has nothing to do with ordinary vision.

The shadows of shadows of shadows of shadows of shadows pass across your retinas invisibly.

TIME

Each of these shadows took place over a certain period of time.

In an atomic explosion, for someone with no optical aids, there are three visible stages: the flash, the fireball, and the mushroom cloud. The flash appears instantaneous; it dims immediately into the fireball, which grows over three or four seconds to the size of the entire sky, dimming and reddening as it grows. The mushroom cloud emerges after the fireball diffuses. Harold Edgerton, the photographer, demonstrated a stage before these three, which is invisible to the unaided eye: the shockwave, which looks like an outlandish sculpture of rotting fruit. Most of his photographs were classified until a few years ago, when there was an exhibition and catalogue of the material. I was very interested in that project, and I wrote about it several times.[1] But it has no

relation to what is in this book; the shockwave took place in the first ten-millionths of a second after the blast.

The time of the shadows of the images in this book begins with the fireball. Here is the same list of five shadows, with their timings:

1. The first shadow, cast by the electromagnetic radiation and particle radiation from the blast, occurred between a ten-millionth of a second and three seconds after the blast.

2. The shadow cast by the sun onto elin's cyanotype paper took ten minutes, and happened sixty-six years after the blast.

3. The shadow cast by the 4 x 5 plate camera's lights onto the photographic plate took place in a fraction of a second—probably on the order of 1/30 second, or 1/60—sixty-seven years after the blast.

4. The shadow cast by the flat-bed scanner moved slowly across the transparency, one fraction of an inch at a time, raster-scanning it. Depending on the resolution, that shadow could have taken several minutes to complete. High-resolution leaf scanning and professional flatbed scanning are among the few remaining kinds of photography that require the subject to remain still, but unlike early cameras they do not see the subject all at once. Like old-fashioned cathode ray TV tubes and contemporary atomic force microscopes, scanners see only one dimension at a time—they see row by row, never all at once.

5. The fifth shadows, the ones being cast on your retinas as you read, have taken place from the first publication of this book, sixty-seven years after the blast, and they will continue on into the indefinite future.

ART HISTORICAL THOUGHTS ON TIME AND SHADOWS

What am I trying to say here?

First, that photography, "the art of fixing the shadow," is not working normally in these images. It is divided into different occasions, and each occasion is invisible. Normally, if I can use that word, visible shadows—trees, people—are "fixed" in a photograph's shadows. LoneBlueBottle looks like a negative of an ordinary photograph, which would have preserved the bottle's ordinary, visible shadow. But it is not, because it records ultraviolet light, and because the shadow it recalls was inhuman, invisible, deadly. Those five occasions of fixed shadows are also temporally distinct: the first was a second long, but no one experienced it; the second was ten minutes long, and elin experienced it. Their durations are as unrelated as the shadows themselves. The photograph itself is a divided thing, separated from its originating event and from its nearest relatives in photography.

I think of this as a challenge for photography criticism, but also for art history.[2] In the discipline of art history, time is understood as a theme in art: in eschatological images, for example, or in *vanitas* paintings, those stocks-in-trade of undergraduate art history. Other art historical forms of time are theorized by writers like Terry Smith or Nicolas Bourriaud, who are concerned with the "heterochronologies," the differing "contemporaneities," of contemporary art. More abstractly, Michael Holly and others are interested by the melancholy of the passing of time, and history's preoccupation with its irretrievable past. Georges Didi-Huberman has written about how art history needs to free itself from the grip of chronology and accept that time, in history, might suddenly disappear, go underground, and then resurface in an entirely new place. And Keith Moxey has written about how historical time can itself be jeopardized—necessarily so—by the insistent presence of the work. All these and others are my professional diet, but I do not want to write about them here. I am interested, instead, in how images like elin's are untouched by them. The time in her images is at once far quicker than the time in art theory—radiation streaming in a burst too rapid and strong for human comprehension—and also far more discrete—light projected several times, in precise ways, causing the object to change each time.

I think of projects like elin's as real challenges for theorizations of time in art. Whatever future writing looks like, it will have to think about these inhuman spans of time: too short, too violent, too experiential, and also too technical to fit comfortably in prose. The brief, the violent, the technical: elements of a poetics of the time of images.

The same, I think, is true of what these photographs are: they are not "fixed shadows" in the usual sense, and they are not even single images of single shadows. That, too, is a challenge for the conceptualization of technical photography, which remains limited to general discussions of "the digital." elin's photographs are certainly part of the current interest in the indexical—in records of objects that are made directly, physically, by their proximity to the paper, the film, the CCD (charge-coupled device). Her rubbings are also indexical, even more insistently so. There are contemporary artists who try to reduce photography to a purely indexical medium. Marco Breuer—another of the four artists for whom I've written essays—has made photographs without lenses (as photograms often are done), but also without enlargers or cameras of any kind, and even without light. In one series, he scraped heated pots across photographic paper in a darkroom, and the heat itself caused photochemical reactions that turned up as red and yellow auras. elin isn't as insistent on the purity of the indexical contact and inscription, but it is appropriate for her project because direct contact evokes the "death shadows."

But I will not rehearse the literature on Peirce, the indexical image, the disembodiment of the digital, the post-medium condition, the technical image, and so forth. It is enough to say that art history has more work to do if it is to think about images whose relation to visibility and shadows, to the digital and the analog, to light and other radiation, is as precisely articulated as it is in elin's images.[3]

BEAUTY, VIOLENCE, AND PAIN

But now I want to shift to my second subject. The first subject was an attempt at a scientific or at least a technical discussion of what happens in elin's photographs, and a very brief look at how this sort of information might appear in art history. My second subject is ethics and aesthetics.

There is a delicate relation between elin's quiet images and the violent, painful pictures that Hiroshima has mainly produced. Those older images are so powerful they are hard to describe: they are searing, visceral, excruciating. elin's are sensitive, tender, and shadowy.

The ethics of elin's shadowy beauty is difficult to understand. It cannot be enough to say that the effects of Hiroshima were themselves unrepresentable. That can't be sufficient, for at least three reasons. First, Adorno made the case against representation in reference to the Holocaust, and that was an incomparable example by definition. Second, Claude Lanzmann has made the case against representation to the art historian Georges Didi-Huberman, but that was regarding a handful of photographs of something otherwise unrepresented, so again it does not pertain to Hiroshima.[4] Third, any number of journalists and government representatives have made the case, urging that the real horrors of war not be shown; but that position is deeply problematic and politically compromised, as Chris Hedges and others have argued.[5] No, it isn't enough to say that the reason elin's images are quiet, minimal, and monochromatic is that the actual events were horrible beyond representation, because in fact those events were massively represented.

I wouldn't be convinced, either, if I were told that it is necessary to turn down the volume on extreme violence in order to make atrocity audible. That argument implies there is something nascent in an image of pain or violence that is not expressive or legible unless the very pain or violence itself is modulated—it's a paradoxical argument, I think, and in the absence of examples I don't find it persuasive.

On the other hand, I can imagine an argument to the effect that it is wrong to conceive the images in this book as primarily political, because they do something else with imaging and imagination. But art and politics are always

entangled. One generation learned that from Foucault; another from Nancy; and now people site Rancière for the same conclusion. At the least, elin's cyanotypes and rubbings are succinct demonstrations of specific political and historical events just because each one represents a complete object, and each object is clearly identified. It would have been easy to do what any number of other artists have done with historically related material: the objects could have been shown only in part, or blurred, distorted, collaged, or otherwise made partly illegible.

Why, then, are the images calm, nearly empty, lovely, and soft? I am concerned that the simplicity of the beauty of her images is in an unproductive contrast with the storm of affect and pain in the original Hiroshima images. In other words: what concerns me is this particular use of beauty to answer something that is not beautiful, this particular absence of explicit pain, this disparity between the formal interests of her images and the ravaging content of photographs and films made in the days following the disaster.

Here is how I think of it. Making images of ladders, bottles, combs, and leaves is a way of saying: I cannot represent what happened to people in Hiroshima, because I cannot re-present it as art. It's not that the people who suffered could not, cannot, or should not, be represented: it is that they cannot be re-presented in a fine art context. All that is left for art is to look aside, at other things, at surrogates, at things so ordinary and empty that they evoke, unexpectedly but intensely, the world of pain. I am not sure if this is ethically sufficient, but I think in this case it feels ethically necessary. I will try to illustrate that with an example, a brief sequence in the film *Hiroshima-Nagasaki, August 1945* by Akira Iwasaki in which doctors demonstrate what remains of a child's hand.[6]

The clip begins with the child's hand, held by a nurse or doctor. At first it is not apparent that this is a hand. I thought it was a foot bundled in a damaged sock. The thumb is at the bottom, and the palm faces toward us. The fingers are burned and possibly fused together. The hand remains frozen throughout the sequence.

A long forceps, holding a tiny swab, is moved gently over the surface of the hand. The nurse, or doctor, swabs the palm. I guess this kind of long forceps is used to pluck foreign material out of wounds. It is not an ordinary tweezers. And the medicated pad of cotton, if that's what it is, is unusually tiny, as if the slightest touch would cause the child to writhe in pain.

The caregiver gently turns the child's hand, or what is left of the hand, and swabs across the palm toward the area that was once the pad of the thumb. It seems that this is staged, but whatever real care this child got, it could not have been effective.

For me, this ten-second sequence is excruciatingly painful. It is hard to watch and hard to think about. The child's body is invisible. There is no sound. The hand is bizarrely charred white. The fingers are apparently burned into a mass. The long metal pincers are unsettling, and the tiny ineffectual swab is clearly useless. The unresisting hand is slowly turned for the camera: perhaps the child is unconscious—I hope so.

If I contrast this sequence with elin's photographs, I can see why images like this are unavailable for, or as, art. Any addition to them would be the same sort of category error that Georges Bataille committed when he put images of the Chinese "death of a thousand cuts" into his *Tears of Eros.* The Chinese photographs were intended to serve as the ultimate examples of transgression, pain, and ecstasy; they were intended to underwrite the surrealist project. But for me they end up making the surrealist paintings and sculptures look weak and even misguided.[7] Images as strong as Iwasaki's cannot be mixed with art: they have to stand in opposition to art, or apart from it, as contrasts, as balances, as reminders of what art is not.

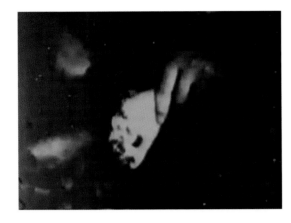

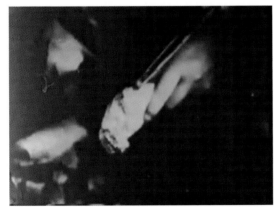

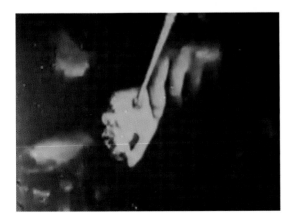

Looking at elin's images and Iwasaki's side by side, I can begin to think of exactly what elin's images are: attempts *not* to see. By themselves, elin's images can seem pretty, empty, and decorative, and therefore also unethical, politically evasive, and even escapist. What shows me that this is not true, and that elin's photographs have found the best route into this material, is that her photographs *answer* the irreproducibility of Iwasaki's images. Let me put that again, more precisely: elin's LoneBlueBottle does not balance, avoid, or retreat from the scene in Iwasaki's film. Rather LoneBlueBottle responds to a particular property of Iwasaki's images: their irreproducibility. Another way to articulate this would be to say that what counts as art, here, is work that can be seen *as representation.* I don't think we see the child's hand in Iwasaki's film as representation. It is the thing itself, the event, the raw suffering, the politics of it, the pain of it. To re-present that as art would mean re-presenting it *as representation,* in such a way that we think of the surface, the technique, the object itself. That is what happens with elin's photographs, intentionally so. If she had used Iwasaki's images as raw material, she would have been mixing presentation with representation.[8]

I have been exploring these issues for myself in several conferences and in a book co-edited with Maria Pia Di Bella, called *Representations of Pain in Art and Visual Culture.* The salient feature of painful images, we found, is that observers tend to forget they are representations.[9] We look at this film of a child's hand, and we think of the child or, selfishly but inevitably, we think of our bodies, the pain we would feel. Even if we are professionals—like the people who come to conferences on this subject—we forget we are studying representations. We are only interested in looking *through* the image, and seeing that child's hand more exactly, or finding out more about the child.[10]

Many artists take strong, violent, painful images, and work into them until they can be represented as art. There are dozens, perhaps hundreds, of artists who make aestheticized

photographs of prisons, old sanatoria and asylums, preserved jars with birth defects, anatomical museums, surgical theaters, morgues, and even scenes of war and torture. All of them, from Joel-Peter Witkin to Rosamund Purcell to Chen Chieh-jen (who uses Chinese photographs of the "death of a thousand cuts"), are embarked on problematic projects that mix immiscible elements.

elin avoids all that, and her avoidance is a necessary move if we are to continue thinking about Hiroshima.

A BRIEF CONCLUSION

This is a sharp, sad, and beautiful project. It is also remarkably complex. In this short essay I have only tried to open two subjects:

1. As photographic representations, elin's images are complex beyond what the theory of photography normally considers.

2. As contributions to the practice of making images of extreme violence and pain, elin's images are exemplary.

Those are my two subjects. I think they are tied together, but the connection is so vast that it would take a book to develop the link. Instead I offer this one sentence:

The technical details of these images—the light that produced them, their increments of time—are the way to understand the language of what is ethically possible in the continuing history of Hiroshima.

ENDNOTES

1 The only link is that the Hiroshima bomb was exploded approximately 1,500 feet in the air. The US government has always claimed it never tested bombs in the US except on towers, or underground; but the material the Roth Horowitz Gallery published from the Edgerton archives shows explosions that were probably set off from bombs in balloons. Even now, the government refuses to acknowledge those photographs; in addition, the places and dates of a number of Edgerton's photographs are censored, and the Department of Energy keeps an unknown number of Edgerton's photographs that it refuses to acknowledge. The catalogue essay for the Horowitz exhibition is revised in "Harold Edgerton's Rapatronic Photographs of Atomic Tests," *History of Photography* 28, no. 1 (2004): 74–81; see also "Harold Edgertons rapatronische Fotografien von Atomversuchen," trans. by Josephine Fenger, in *Atombilder: Ikonographien des Atoms in Wissenschaft und Öffentlichkeit des 20. Jahrhunderts*, ed. by Jochen Hennig and Charlotte Bigg (Berlin: Wallstein Verlag, 2009).

2 I have written about images of even shorter durations (nanoseconds, picoseconds, femtoseconds) in "On Some Limits to Film Theory (Mainly from Science)," in *Cinema and Technology: Cultures, Theories and Practices*, ed. by Bruce Bennett, Marc Furstenau, and Adrian Mackenzie (Houndsmills, Basingstoke, Hampshire, England: Palgrave Macmillan, 2008 [New York: St Martin's Press LLC]), 53–70.

3 There are other ways art history could address these images, without needing to think about the specific conditions of representation I have mentioned. For example elin's work is part of the aesthetic of the everyday, a category that is usually assigned to Michel Du Certeau (who was concerned with the ways our ordinary lives are the conditions of our larger social and political contexts), to Brian Massumi (where uncognized ordinary experience is the ground of political life), or to romanticism (where the everyday meant things that are overlooked, marginal, discarded, and therefore especially poignant and eloquent). But in the scope of this essay I thought it was more important to put down some basic facts about the representations.

4 The controversy was about the publication of previously unknown photographs of people being led into gas chambers. Lanzmann's position was that no such images should be reproduced. See Georges Didi-Huberman, *Images In Spite of All: Four Photographs from Auschwitz* (Chicago: University of Chicago Press, 2012).

5 Briefly, Hedges's argument against people who argue that some images should be withheld by the media, or by governments, is that their principal justification for doing so can only be their interest in keeping the most incendiary images in reserve so they can be used to agitate people when it is morally imperative. Hedges maintains that all images should be shown, precisely so that the media and governments do not have the capacity to incense people by deciding when to show images that are exceptionally violent or painful. See his *War Is a Force That Gives Us Meaning* (New York: PublicAffairs, 2002).

6 These are screen grabs from the low-resolution YouTube upload, youtu.be/p1cX1kcjDgA, at 5:35. The story is retold in youtu.be/5Q-bee24J7c.

7 James Elkins, "The Most Intolerable Photographs Ever Taken," in *The Ethics and Aesthetics of Torture: Its Comparative History in China, Islam, and Europe*, ed. by Timothy Brook and Jérôme Bourgon (London: Rowman and Littlefield, 2012).

8 I remember after 9/11 there were impromptu galleries set up just north of the site; at least one was open to anyone who wanted to contribute an image. Some photographs in the gallery were manipulated to make the skies redder, or the smoke denser. One had been put in Photoshop; others had been drawn or painted over. At the time, the *Chronicle of Higher Education* had asked me to write something about imagery after 9/11, but I knew that I couldn't write about those images in the way I wanted. I would have asked why the event wasn't terrible enough on its own terms, why it needed ornamentation to make it expressive.

9 This is especially clear in the round-table discussions that end the book, in which the conference participants slide from speaking about photographs, prints, and film to speaking about events, people, and legal issues. See *Representations of Pain in Art and Visual Culture*, co-edited with Maria Pia De Bella, in the series Routledge Advances in Art and Visual Studies (New York: Routledge, 2012).

10 This lapse of professionalism is also an ethical moment, an untheorized release from the agnostic positions of scholarship. The fact that visceral pain caused the ethical awareness, rather than a reasoned sense of obligation, doesn't occur to us. Nor did my colleagues or I notice that when we returned to studying representations, our return was impelled by that same professionalism: not an ethical change, but a simple matter of duty and habit.

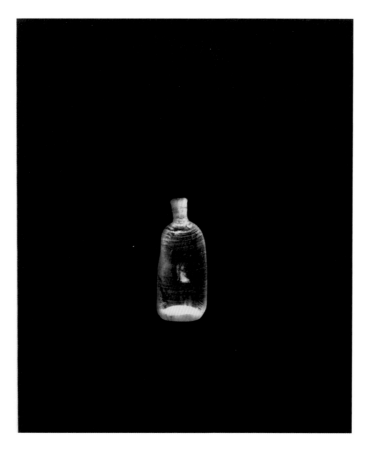

瓶のイメージについて

ジェイムズ・エルキンズ

エリン・スラヴィックについてエッセーを書くことは、私にとっていくつかのことを意味する。まず、エリンは私のかつての学生であり、以来何年にもわたって連絡を続けている。彼女の執念の対象は視覚的なものであり、その視覚的センスは倫理的であり、その倫理的関心は楽しみであって、彼女の仕事は三要素のすばらしい組み合わせとなっている。それを私はつねに好ましく思ってきた。それゆえ彼女の依頼を受けたとき、美と時間と痛みについて少しく考えることにより、ひとつの交友関係に報いるよい機会になるだろうと思った。

第二に、美術家のためにエッセーを書くことは、私が普段やり慣れていることからいって、例外である。美術家のための紹介文を私はたしか四編しか書いていない。しかもその一つはヴィク・ムーニスのために書いた長い文章であったが、私の見る限りではそれがもとで彼との関係は破綻し、書いた文章は読まれずじまいとなった。総じて、美術家の本に寄せた紹介文エッセーというものは、あまり参考にされない。そうしたものは、美術家とその画廊の一時的な関心事に寄与はするが、現代美術について進行中の会話にはあまり寄与しないからだ。しかし今度は違うと思う。エリンの関心事は、写真芸術のいくつかの営みにおいて表面化しつつあるからだ。

第三に、これは、通常の紹介文の枠を超えて、美術についての書き物の流れに寄与する機会であると思われる。いま念頭にあるのは、エリン自身の文章と、そしてエリンの友人であるキャロル・メイヴァーの何冊かの本である（キャロルはシカゴ美術館付属大学で短期間教えたことがあり、エリンが私の学生であったのも、その同じ大学でのことだ）。キャロルの著書は、声とそれへの個人的なかかわり合いが展開してゆく感覚という名のもとで、通常の美術史のまわりをめぐり、下をくぐる。学問に携わる者なら誰でもエクリチュール（書く営為）と真実ということをロラン・バルトから学んできたと思うが、それを彼女もバルトから学び、学んだことについてたんに学問的な分析を書くのではなく、実際に活用するのだ。

第四に、このエッセーは、非常に大きな、じつはほとんど宇宙規模の思考を口にする機会である。学問の場では、900ページの博士論文を書くか、教授歴の終わり近くに畢生の代表作を書く場合でなければ、話題にできないような部類のものだ。しかし、エリンの作品のコンテキストにおいて、美の倫理性および時間と苦痛の表現について、いくつか役に立つことが言えるように思う。一友人への義理と、自由に書く機会とが一致したことで、たぶん、私の抽象的な話題に望ましい温かみが添えられることかと思う。

いくつかの事実を、科学者が見るように見ることから始めよう。そのうえで、美術家はじめ、美術関係の批評家・理論家・歴史家・哲学者らが見るような目で、それらの事実を見ることへ移りたい。そうすることで、それらのイメージが独特の表現構造――表現された出来事への特殊で複雑な関係――を持つこと、そして現今の写真理論はその複雑性をまだ十分に評価していないことを、示したいと思う。

そのあと、2，3ページを割いて第二の話題を扱いたい。痛みの表現において倫理がどう美につながるか、である。ヒロシマのような事象を、そんなにも単純で美しく装飾的な一つのイメージで表現することは、はたして倫理的だろうか。作品が実際の歴史的意味を持つとき、その歴史上の出来事にかかわる人にとって、それはたやすく答えられる問題ではない。そして、もし美術がヒロシマのような事件に問いかけることを続けるとすれば、エリンの作品はまさに本筋にあると思う。私は、第一の話題（イメージの技術的な細部）と第二の話題（この特殊な過去を表現することの倫理的な問題）を結びつけるような一個の文章で結論づけたい。

エリンからの電子メイルのひとつにあった「孤青瓶」（LoneBlueBottle）と呼ばれる画像を使おうと思う。（その題名は単語間のスペイスなしに詰めてあり、詩的でありながら事実に即してもいる。）

四つの影

私の見るところ、このイメージが即座に注意を惹くのは、それが、人間の生み出した最も強烈な光の照射のあとの、ぼんやりと青みがかった残像だということからである。

さらに量的に表現してみよう。私の言いたいのは、この本の中の画像はみな、影の影の影のまたその影だということだ。

それぞれの影は、ことなる光によって投影された。

（以下、いささかの科学用語を使うが、できればお読みいただきたい。クリスチャン・ベックの繊細な小さい本『結晶学』のように、科学を用いた観念詩だとお考えいただきたい。）

1. 最初の影は、広島の記念資料館に保存されている物件が、核爆発の放射線に打たれたときに落としたものである。これらの影に投じられた光は8種類の放射線を含んでいた。

i 赤外線、マイクロ波、および電波で、どれも波長の長いフォトン（光子）である。これらに起因する熱が、上に挙げた瓶を溶かし始めたはずだ。この3種類を合わせて、通常「熱放射」と呼ぶ。

ii 可視波長の光。これを見れば目が眩んだはずだ。

iii 紫外線。上の2種類と同様、これもフォトンから成る。その強度から、やはり目が眩んだはずだ。

iv アルファ線、これはヘリウム原子核の流れである。それらはプルトニウム、ウラニウム、ラドン、およびラジウムの崩壊によって放出される。この瓶の中の水は――もし水が入っていたとすれば――アルファ線を遮蔽し、影を投げただろう。

v ベータ線、これは電子である。炭素、リン32、ストロンチウム90、およびトリチウムの崩壊によって放出される。ベータ線もこの瓶の中の液体によって遮られ、影を投げただろう。

vi ガンマ線、これはフォトンである。コバルト60とセシウム137の崩壊によって放射される。影を投げることなく瓶をそのまま通過したはずだ。

vii X線、これもフォトンである。高エネルギーのX線は瓶を通過しただろう。低エネルギーのX線は部分的に吸収され、このイメージにあるような影を投影した可能性がある。

viii 中性子、これはバリオンの一種である（さらに、バリオンはハドロンの一種）。これはウラニウムとプルトニウムの核分裂によって生成される。瓶を通過し、なんの相互作用もなかったはずだ。

このうち、アルファ線、ベータ線、ガンマ線、および間接的には中性子をも含めて、バリオン電離放射線と総称する。これらが核爆弾炸裂の後に続いた原爆病の大半の原因である。しかしそれはエリンのテーマではない。この場合のオブジェは単純にガラスである。

ところで、私はすでに幾つかの間違いをおかしてしまった。可視波長の光と紫外線の光で眼がくらむというべきではなかった。この瓶のそばにいた人は、瞬時に灰と化したはずだからである。また、アルファ線、ベータ線, ガンマ線は影を投じるというべきではなかった。なぜなら、これらは人間の眼には見えず、この瓶のそばにあった眼は灰と化したはずだからだ。

原子爆弾炸裂の後、人間、機械、橋の欄干、梯子、そして樹木の「死の影」には、目に見えるものもあった。それらの周囲の表面が焦げたり漂白されたりした場合である。主な原因は「熱放射」すなわち赤外線、可視波長光、紫外線から来る熱である。これらの波長の光は多く、1秒から3秒という短い時間内に発生し、それが気化冷却を妨げた。原子爆弾の炸裂した上空の真下を爆心地というが、その近辺では、熱放射は1平方センチメートルにつき125ジュールを超えた。可燃性の物がすべて燃え、その周囲に影を投じるに十分な量である。しかし、この特定の瓶がそのような影を投じたという記録はない。

この瓶は、おそらく「死の影」を投影しなかったであろう。もし投影したのであっても、その記録はない。そしてそのとき、この瓶が投げたかもしれない別の種類の影を見る目も存在しなかった。X線が上に書いたように「このイメージにある」ような影を投げるためには、瓶はX線に感光する紙の上に置かれていなければならなかった。

だから、この瓶の最初の影は、目に見えなかったことになる。それも幾重もの意味においてであって、まず「死の影」は記録されていない。次にその他の影も人間の眼の認めうる範囲外の、粒子やフォトンの投じたものだ。そしてこの瓶を目にすることができるほど近くにあった眼は、灰と化したはずだ。

2. 第2の影は、広島の記念資料館に保存された、いくつかのオブジェをエリンが青写真紙（シアノタイプ紙）にのせて太陽に当てたときに投影された。「孤青瓶」は影である。その影を投げた光は、同じ8種類の放射線を含んでいたが、強度も割合も非常に異なる。紙の上に認められた放射線はただ、

iii の紫外線だけで、紙の鉄分を酸化鉄(III)から酸化鉄(II)に、つまり酸化第二鉄を酸化第一鉄にする。中間的な段取りを経て得られる結果は、画家にはプルシャンブルー、$Fe_7(CN)_{18}$ として知られる。

この影を投じたものは、それ自体は目に見えない。だから、その時点においてはなんの影もなかった。もっと正確にいえば、青写真を準備したときにエリンが影を見たとしても、それはその青写真に記録された影ではなかった。

その青写真は決して目に見えなかった一個の影を記録する。記録された影は決して目に見えなかった一個の影を呼び戻す。

3. 第3の影は、エリンがこの本のためにこの青写真を撮影したときに投じられた。エリンは大画面カメラを用い、そして第3の影が縦4インチ横5インチのネガに投じられた。おそらく、撮影用スタンドに当たる光は、

ii の可視波長の光で、いくつかの温度（5600K、4200K、3200K）のうちの一つに色を調整したものだろう。

これは目には見えるはずだが、おそらくエリンは見なかっただろう。写真家は、感光中にはネガを見ないからだ。いったんネガが現像されてからなら見たかもしれないが、それは青写真の影の影ということになろう。

4. ついで、その4インチ x 5インチのイメージはこの本のためのデジタル写真原板としてスキャンされた。平面台スキャナーが4 x 5のネガ、つまり4 x 5の色刷り透明紙を読み取った。スキャナーの光も通常、

ii の可視波長光で、いくつかの温度（5600K、4200K、3200K）のうちの一つに色調整される。

これも見えなかったはずだ。スキャナーに入れた透明紙には蓋がかぶせてあるからだ。

5. この本の中の画像群は、影の影の影の影である。それらもまた、読者がページをめくるたびに目の網膜に影を作る。おぼろげで曲がったそれらの影も、読者には見えない。デカルトが最初に指摘したように、我々には目の中の影は見えないのだ。それらがどのような姿であるかを我々は意識しない。我々はそれらが存在することを知っているだけだ。私は眼科医の細隙灯顕微鏡で、人の目の中の影を見たことがある。驚くべき経験ではあったが、それは通常目に映るものとは関係ない。

影の影の影の影の影は、不可視のまま目の網膜をよぎる。

時間

これらの影はすべて、一定の時間を経過する。

視覚補助具を持たない人にとって、核爆発時には3段階の目に見える現象が起こる。閃光、火の玉、キノコ雲である。閃光は瞬時に現れる。それはただちに薄らいで火の玉となり、さらに薄らぎ赤くなりながら3、4秒で空全体の大きさに広がる。火の玉が拡散したあと、キノコ雲が出現する。電気工学者で写真家のハロルド・エジャートンは、これら3段階のそのまた前の、視覚補助具なしには見られない段階を撮影した。それは衝撃波の写真で、腐りかけた果物の異様な彫刻のように見える。彼の写真の大部分は数年前展示され、カタログも出たが、それまでは機密扱いされていた。私はその企画に大変興味を抱き、何度かそれについて書きもした。しかしそれはこの本の中にあるものとは無関係である。[1] 衝撃波は核爆発後、最初の1秒の千万分の1のあいだに起こったものだ。

この本の中のイメージの影の時間は、火の玉から始まる。同じ5種類の影を、時間を付して示してみよう。

1. 第1の影、爆発の電磁波の放射と粒子の放射により投じられたもので、爆発後千万分の1秒から3秒のあいだに起こった。

2. 太陽光によってエリンの青写真紙に写された影は、10分かかり、爆発後66年に起こった。

3. カメラの光によって4×5インチの写真板に落とされた影は、1秒の何分の1かの時間——たぶん30分の1か60分の1——に、爆発後67年を経て起こった。

4. 平面台スキャナーによって投影された影は、透明紙の上をゆっくりと、1インチの何分の1かの割合で動き、ラスタースキャンが行われた。解像度によっては、数分かかったかもしれない。高解像度リーフ・スキャニングと専門用平面台スキャニングは、被写体を静止させておくことを要求する写真術のうち、わずかに残る例であるが、初期のカメラと違って、対象を一度には捉えない。昔風のTVブラウン管や今日の原子間力顕微鏡と同じく、スキャナーは一度に一つの範囲しか見ない。つまり一列ごとに走査するのであって、決して全部をいちどきには見ない。

5. 第5の影は、読者が読むときに網膜に映るもので、核爆発の時から67年を経てこの本が出版されたときに始まるが、これからも、いつまでかは分からないが、未来へと続くだろう。

時間と影についての美術史的思考

さて、ここで何を言おうとしているのか。

まず、「影を捉えて固定させる技術」たる写真術は、通常、これらのイメージの中で作業しているわけではないということ。さまざまな時点に分かれ、それぞれの時点が目には見えないのだ。通常、もしあえてそういう言葉を使うなら、目に見える影——樹木や人々——は写真の影の中に「固定」させられる。「孤青瓶」は、目に見える影を保存した通常の写真の陰画のようにも見える。しかし、そうではない。それは紫外線を記録し、その影は非人道的、不可視的、致死的なものだからだ。捉えられた影のこの5段階は、継続時間的にもはっきり分かれている。第1は1秒続いたが、誰もそれを経験しなかった。第2は

10分続き、それをエリンは経験した。それらの影同士は無関係だが、継続時間も同じく無関係だ。その写真自体、分離したもので、そのもとになる事件や写真術における最も近親のものからも離れている。

私はこれを写真批評にとってのチャレンジだと考えるが、美術史にとってのチャレンジでもあるのではないだろうか。[2] 美術史の研究分野では、時間は芸術における一つのテーマとして理解される。たとえば、学部の美術史では常套手段となっている終末論的なイメージや、あるいは虚無的な絵画の中で。時間に関するほかの美術史の形は、現代美術の「異時間」すなわち「ことなる現代性」に興味を抱くテリー・スミスやニコラス・ブーリオーが、理論化している。マイケル・ホリーその他は、過ぎゆく時間への憂愁と、元に戻らぬ歴史の過去への執着に興味を抱いている。ジョルジ・ディディ＝ユベルマンは、美術史が時間から解き放たれて歴史的時間が急に姿を消し、地下に潜り、全く新たな場所で再び表面化する可能性を受容しなければならないと書いた。また、キース・モクシーは、歴史的な時間そのものが、当然ながら作品の執拗な現在性によって、存在を危うくされかねないことを書いた。これらすべては、ほかの書き物とともに、私の職業的に摂取するところであるが、ここではそれらについて書こうとは思わない。むしろ私が興味を抱くのは、エリンのイメージのようなものが、彼らの触れるところではないという事情である。彼女のイメージにおける時間は、人間の理解を超える速度と強烈さを持つ核爆発放射線にかかわるのだから、美術理論における時間よりも速い。かつ同時に控えめでもある。繰り返し正確に投影し、オブジェをその度に変化させる光を扱うのだから。

エリンの作品のような取り組みは、美術において時間を理論化することへの本当のチャレンジだと私は考える。将来の書き物がどのようになろうとも、それはこのような超人的な時間の枠について考えなければならないだろう。それは、あまりにも短く暴力的で経験的であり、かつあまりにも技術的なので散文にはやすやすとなじまない時間枠である。

同じことがこれらの写真のなんであるかについても言えると思う。それらは普通の意味での「固定された影」ではないし、個々の影の個々のイメージでもない。そのこともまた、専門的な写真芸術の概念化にとってはチャレンジである。その概念

化は「デジタルなるもの」の一般的な論議に限定されるからである。指標的映像とは、紙やフィルムやCCDイメージセンサーへ近づけることによって、直接、物理的に物体を記録したものをいうが、最近それへの興味が高まっている。エリンの写真は確かにその一端ではある。エリンの擦り物（ラビング）も、指標的、というか、写真よりさらに強烈に指標的である。今日の美術家の中には, 写真を純粋に指標的な媒体にしようとする人々もいる。マルコ・ブロイアーは――私がエッセーを寄せた四人のうちの一人であるが――（フォトグラムがしばしばそうするように）レンズなしに写真を撮っており、また引き伸ばし機もカメラも一切なしに、光さえも使わずに撮影することもある。ある一連の写真では、熱した鍋をいくつか写真紙の上に暗室でこすりつけ、熱自体が光化学的反応を起こして、赤と黄のオーラとなった。エリンは指標的コンタクトと刻印の純粋性にそれほどこだわらないが、擦るというのは彼女の取り組みにはふさわしい。直接のコンタクトは「死の影」を喚起するからである。

しかし私はチャールズ・サンダース・パースについての文献、指標的映像、デジタルなもの分離、媒体後の状態、技術的映像、などを復唱するつもりはない。エリンのイメージなどにおいては、まさに映像の可視性や影、デジタルとアナログ、光その他の放射への関係が表現されている。そうした関係について考えるのであれば、美術史にはまだまだすべき仕事がある、といえば十分だろう。[3]

美、暴力、苦痛

しかしここで、第二の話題に移りたい。第一の話題は、エリンの写真群において何が起こるかについての科学的な、少なくとも技術的な考察で、美術史においてこのような情報がどのように現れるかについてごく短く触れた。第二の話題は倫理と美感についてのものである。

エリンの静かなイメージと、主に広島からの暴力的で痛々しい画像とのあいだには、微妙な関係がある。これら古いほうの画像はあまりにも強烈で描写しがたい。焼けつくように腹の底にこたえ、身を切られるようだ。エリンのイメージは繊細で、やさしく、陰影に富む。

エリンの陰影美は、理解しがたい。ヒロシマの惨禍自体が描写不可能であるというだけでは、言い足りない。それでは不十分である。少なくとも三つの理由がある。第一に、アドルノはホロコーストに関連して表現することに反対した、そしてそれは当然ながら比較できない例であった。第二に、クロード・ランズマンは、美術史家ジョルジュ・ディディ＝ユベルマンにたいして反対をとなえたが、それは何枚かの、それ以外には表現されないものの写真についてであり、これまたヒロシマに関連するものではない。[4]　第3に、ジャーナリストや政府代表が何人となく主張することだが、戦争の本当の惨事は見せるべきではないという。しかしこの立場は、深く問題をはらみ、政治に譲歩的であることは、クリス・ヘッジェスその他が論ずる通りである。[5]

もし、激しい暴力場面で、その残虐性がさらによく聞こえるようにするために音量を下げる必要があると言われても、納得できないと思う。そういう議論は、苦痛や暴力のイメージには、本来的に、その苦痛や暴力自体、調節されなければ、よく表現されず読み取れないという主張を言外に含める。それは逆説的な議論だと思う。実例がないので、説得的だとは考えられない。

他方、この本の中の画像が主に政治的であると考えては間違いだという意味の議論も想像できる。これらの画像は、創造と想像（イメージ作りとイマジネイション）で政治以外のことをするからだ。しかし美術と政治とはいつも絡まりあっている。ある世代の人々はそれをミシェル・フーコーから学び、別の世代の人々はジャン＝リュック・ナンシーから学び、いまでは人々は同じ結論を引き出すためにジャック・ランシエールを引用する。少なくとも、エリンの青写真と刷りものは特定の政治的歴史的出来事を簡潔に表示する。それぞれが一つの完全なオブジェを表し、それぞれのオブジェが明確に確認されるという単純な理由からだ。大勢のほかの美術家が歴史的関連性を持つ題材で行ったことをするのは簡単だっただろう。オブジェは部分的に示されてもよかったし、あるいはぼかされ、歪曲され、コラージュされ、ほかにも部分的に読み取りにくくできたはずだ。

ではなぜ、これらのイメージは静かで、空白に近く、愛らしく、柔らかなのか。エリンの画像の美の単純さは、もともとのヒロシマの画像の感情と苦痛の嵐との非生産的な対照にあるの

ではないかと思う。言い換えれば、気になるのは、美しくない
ものに応えるにこのように美を以てする姿勢、表立った苦痛
の不在、イメージへの形象的な興味と、一方惨事に続く日々
に作られた写真やフィルムのあらわす荒漠たる内容、その両
者のあいだの隔たりである。

私の考えはこうだ。梯子、テカウンター、瓶、櫛、木の葉などの
画像を創るということは、「私は広島の人々に起こったことを
表現できない、それを美術として再現できないから」と言って
いること、そのひとつの言い表し方だと思う。これは、苦しんだ
人々が表現され得なかった、され得ない、されるべきではな
い、ということではない。彼らが美術のコンテキストにおいて
は、再現され得ないということだ。美術に残されたことは、目
をそらせ、別のものを見、代替物を見ることを、あまりにも日
常的でうつろなため、かえって思いがけず、強烈に、苦痛の世
界を喚起するもろもろのものを、見ることのみだ。これが倫理
的に十分であるかどうか分からないが、この場合には倫理的
に必要であるように思う。一例を以てそれを説明したい。それ
は岩崎昶の映画の中の短い一続きの場面で、医者が子供の
手を、というよりはその残存部分を、示している。[6]

まず、看護婦か医師かが持っている子供の手で始まる。初め
はこれが手であることもはっきりしない。私は損われたソック
スに包まれた足だと思った。親指が下で、手の平がこちら向
きになっている。指は焼かれ、くっついているようにも見える。
場面のあいだ、手は静止したままである。　小さな綿を挟ん
だ長いピンセットが手の表面をそっと動く。看護婦か医師か
が手のひらを綿でなぞっているのだ。このような長いピンセッ
トは傷口から異物を拭き取るために使われるのだろう。通常
のとげ抜きではない。薬を染ませた綿のようで、非常に小さい
が、かすかに触っただけでもその子供は痛みに身をよじるの
ではないかと思われる。

介護者はそっと子供の手、というより子供の手のうち残った
部分だが、その向きを変え、手のひらから、親指の腹であった
はずの部分へ向けて綿を動かす。これは演出されているよう
に見えるが、実際の治療がどのようなものであったにせよ、効
果があったとは思えない。

私にとって、この十秒間の場面はたいへん苦痛であった。観
るのもつらいし、それについて考えるのもつらい。子供の体は

見えない。音も聞こえない。手は焼かれて奇妙に白くなってい
る。指は焼けて一かたまりになったらしく見える。長い金属の
ピンセットはこちらを不安にさせ、そして小さな、無駄とおぼ
しい綿は明らかに役に立たない。手は抗いもせずにゆっくり
とカメラの方へ向けられる。多分子供は意識を失っているの
だろう——そう願う。

この場面をエリンの写真と対照させると、なぜこのような映
像が美術には、あるいは美術としては、利用できないかが分
かる。映像に少しでも付け足せば、ジョルジュ・バタイユが中
国の「凌遅刑」(切り刻みの刑)の画像を『エロスの涙』に入れ
たときのような範疇的誤りとなるだろう。中国の写真は犯罪、
苦痛、および宗教的恍惚感の究極的例となるはずであった。
シュールレアリストの取り組みを支えることが意図されたの
だ。しかし、私にとっては、それはシュールレアリスムの絵画や
彫刻を、弱く、あやまったものにさえ見せてしまった。[7] 岩崎の
映像ほどに強烈なものは美術と混同することはできない。それ
らは美術と相対し、あるいは分離し、対照として、バランスと
して、美術がそうでないものを思い出せるものとして、存在し
なければならない。

エリンのイメージと岩崎のイメージを並べ見て、私はエリンの
画像があえて見ようとしないものがまさに何であるかを考え
始めることができるように思う。それ自体では、エリンの画像
は美しく、空虚で、装飾的、それゆえに非倫理的で政治的につ
かまえ所がなく、現実逃避にさえ見える。それが真実でないこ
と、そしてエリンの写真がこの題材への最良の道を見つけた
ことを私に示すもの、それは彼女の写真が岩崎のイメージの
再現不可能性に答える、ということだ。もっと正確に言い換え
るならば、エリンの「孤青瓶」は岩崎のフィルムの場面をバラ
ンスしたり、避けたり、そこから後ずさりしたりしない。むしろ、
「孤青瓶」は、岩崎のイメージの一つの独特な特性である再
現不可能性に反応する。別の言い方をすれば、美術として大
切なのは、再表出(リプレゼンテイション)として見ることので
きる作品だということだ。岩崎のフィルムの中の子供の手を、
我々が再表現として見るとは私は思わない。それはそれその
ものであり、出来事であり、生々しい苦難であり、その政治学、
その痛みである。それを美術として再び表出しなおすことは、
それを新たな表現として再提示し、その表面や技術やオブジ
ェそのものについて考えさせるような形にすることを意味す

る。それが、エリンの写真で起こっていることであり、そのように意図されている。もしエリンが岩崎のイメージを素材として使ったならば、結果として、表出と表出し直しとを混同することになったことだろう。[8]

私はこれらの問題点を自分のために幾つかの学会で、そしてマリア・ピア・ディ・ベッラとの共編である本、『美術と視覚文化における痛みの表現』(Representations of Pain in Art and Visual Culture)で、探求してきた。私たちの見いだしたのは、苦痛のイメージの目立つ特徴は、それらが再表現であることを観る人々が忘れるということだ。[9] 子供の手のフィルムを見て、私たちは子供のことを、または身勝手ながら必然的に私たち自身の体のことを、私たちの感じる苦痛を、思う。こうしたことをテーマとする学会に来る人々のような専門家であっても、人々は再現されたものを眺めていることを忘れる。私たちはイメージを通して見ていること、子供の手をもっと正確に見ること、あるいはこの子供について知ること、などにのみ興味を抱く。[10]

多くの美術家は、強く激しく苦痛に満ちたイメージを選び、それらが美術として表現されるまで練りあげてゆく。刑務所、古い結核療養所、避難所、先天性欠陥の保存瓶、解剖資料館、手術の場面、遺体安置所、さらに戦争や拷問の場面までを審美化された写真にするアーティストは何十人も、おそらく何百人もいる。彼らは皆、ジョエル＝ポーター・ウィトキンからロザムンド・パーセル、陳界仁(彼は「凌遅刑」の中国の写真を使う)にいたるまで、混和しない要素を混ぜるという難題に取りくんでいる。

エリンはそれらすべてを避ける。そしてもし我々がヒロシマについて考えつづけるならば、その回避は必要な動きであろう。

短い結論

この本は鋭く、悲しく、美しい企てである。それは目覚ましく複雑でもある。この短いエッセーで、私はたんに二つの話題を提起したに過ぎない。

1. 写真表現として、エリンのイメージは写真理論が通常考慮する以上に複雑である。

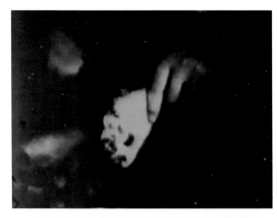

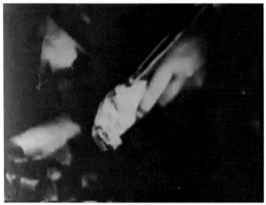

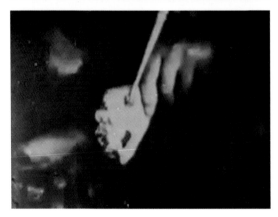

2. 極端な暴力と苦痛のイメージを作る営みへの寄与として、エリンのイメージは代表的である。

これらが私の二つの話題である。両者は互いに結ばれているが、その結びつきはあまりにも広大なので、二者のつながりを十分に極めるには一冊の本を要しそうだ。そのかわりとして私はこの一文を捧げたい。

これらのイメージの技術的な詳細――それを所産した光、時間のかかり方など――はヒロシマの今なお続く歴史において、なにが倫理的に可能であるか、それを語ることばを理解するための手助けとなる。

ENDNOTES

1　ただ一つのつながりは、ヒロシマの原子爆弾が1,500フィートほどの上空で炸裂したということである。米政府は、米国は塔の上か地下でしか原爆実験をしたことがないと常に主張してきた。しかし、エジャートン古記録からロス・ホロウィッツ・ギャラリーが公にした資料には、気球に入った爆弾から発したらしい爆発がいくつか見える。今でも、米政府はそれらの写真を認めたがらない。さらに、エジャートンの何枚かの写真の撮影場所と日付は検閲にかかっており、エネルギー省は、数はわからないがエジャートンの写真を保管しておりながら、認めてはいない。ホロウィッツ展のためのカタログ・エッセーは、改訂版「ハロルド・エジャートンの原爆実験のラパトロニック写真」が『写真史』に掲載されている(History of Photography 28, no. 1, 2004: 74-81)。『原子絵――20世紀の科学と公開性における原子の図像』収録、ジョセフィーネ・フェンガー訳「ハロルド・エジャートンの原子実験のラパトロニック写真」も参照 (Atombilder: Ikonographien des Atoms in Wissenschaft und Öffentlichkeit des 20. Jahrhunderts, ed. Jochen Hennig, Charlotte Bigg. Berlin: Wallstein Verlag, 2009)。

2　私はさらに短い時間(ナノ秒、ピコ秒、フェムト秒)にかんして、「フィルム理論のいくつかの限界について(主に科学から)」(『シネマと科学技術――文化、理論および実践』所収)に書いている(Cinema and Technology: Cultures, Theories and Practices, ed. Bruce Bennett, Marc Furstenau and Adrian Mackenzie, Houndsmills, Basingstoke, Hampshire, England: Palgrave Macmillan, 2008 [New York: St. Martin's Press LLC], 53-70.)

3　こうしたイメージについて、私が挙げた特定の条件について考慮せずに美術史で取り組む他の方法もある。日常の美学というカテゴリーがあり、通常ミシェル・デュ・セルトー(我々の日常生活が大きな社会的政治的コンテキストの条件であることに関心を抱く)や、ブライアン・マッスミ(見過ごされる日常の経験が政治生活の地歩である)、あるいはロマンティシズム(日常というのは見過ごされ、取るに足らないものとされ、捨てられ、それゆえとりわけ痛切であり雄弁でもある)、と関連付けられるが、たとえば、エリンの作品はその一部でもある。しかしこのエッセーの限られた範囲内では、本書の画像の基本的な事実を記述するほうが大事だと考えた。

4　その論争は、ガス室に連行される人々のそれまで知られなかった写真の公表についてであった。ランズマンの立場は、そのような画像は再生すべきではないというものだった。

5　手短かに言えば、イメージによってはメデイアに出さないほうが良いとする人々に反対するヘッジェスの議論は、そうすることの主な理由は、もっとも刺激的な画像は控えておき、道徳的に急を要するときに人々を扇動するために使うことへの興味でしかあり得ないということだ。ヘッジェスはいつ例外的に暴力的、あるいは苦しい画像を見せ人々を怒らせるか、その力をメディアや政府が持たないようにするためにこそ、すべての画像は見せられるべきだという。『戦争は我々に意味を与える力である』(War Is a Force That Gives Us Meaning, 2002)参照。

6　低解像度のYouTubeより。youtu.be/p1cX1kcjDgA, at 5.35. 同じ映像はyoutu.be/5Q-bee24J7cにも含められている。

7　『拷問の倫理と美学――中国、イスラム、ヨーロッパにおける比較歴史』所収、ジェイムズ・エルキンズ「かつて撮影されたものの中で最も堪え難い写真」(James Elkins, "The Most Intolerable Photographs Ever Taken," in The Ethics and aesthetics of Torture: Its Comparative History in China, Islam, and Europe, ed. by Timothy Brook and Jérome Bourgon. London: Rowman and Littlefield, 2012).

8　9/11のあとで、跡地のすぐ北に即席の画廊がいくつか設けられたのを覚えている。少なくとも一つの画廊には、希望者はだれでもイメージを持ち寄ることができた。その画廊に展示された写真のうち、何枚かは修正されて空が実際よりも赤く、あるいは煙が濃かった。一枚の写真はPhotoshopで扱ってあり、ほかの何枚かは上から色が塗ってあった。当時、『高等教育』(The Chronicle of Higher Education)から9/11以降の画像について何か書くように依頼してきたが、私は自分が書きたいようには書くことのできないことを知っていた。なぜ事件がそれ自身、恐ろしいものではなかったのか、なぜそれが表現力を得るために装飾される必要が在るのか、というのが本心であった。

9　これは本の終わりの座談会でとりわけ鮮明となった。座談会では、学会の参加者は写真、版画prints、フィルムについて話し合うことから、出来事、人々、法的問題について話し合うことに移った。マリア・ピア・デ・ベッラとの共編『美術と視覚文化における痛みの表象』参照 (Representations of Pain in Art and Visual Culture, coedited with Maria Pia De Bella, in the series Routledge Advances in Art and Visual Studies. New York: Routledge, 2012).

10　このプロ意識の欠如は倫理的なものでもあり、学問の不可知論的な立場から論理的根拠なく離れることである。理性的な責任感というより、体に応える苦痛が倫理的な意識を呼び覚ましたことを、私たちは気付かない。私の仕事仲間も私も、表彰の研究に戻ったとき、それがその同じプロ意識に駆られてのものであったこと、倫理的な変化ではなく、責任と習慣という単純なことであったこと、に気付かなかった。

AFTER HIROSHIMA

elin o'Hara slavick

The first memory I have of Hiroshima is standing in Monument Square with my parents on Hiroshima Day, August 6, sometime in the 1970s, in my hometown of Portland, Maine. My father spoke. My mother spoke. I tried to speak. I had chosen a firsthand account of the atomic bombing, written by a woman who survived it as a little girl. I could barely read it, choking on her memories of melting skin, maggots in the brain, losing her mother, her father, the disappearance of the world as she knew it.

My six siblings and I were all taught: to finish the food on our plates because there were starving children; to boycott Gallo wine, grapes, and lettuce in support of Cesar Chavez's battle for farm worker rights; to know and be unhappy about what was going on in the world—war, inequality, injustice, hunger, greed. Our parents took us to Europe often, as my mother was a German citizen. Growing up in Stuttgart, a dud bomb had fallen on her childhood bed and her aunt threw it out the window with a dustpan. She survived World War II because her parents moved the family to the tiny town of Kochersteinsfeld. My parents showed us glorious churches, the beautiful countryside, every open museum, *and* the Dachau concentration camp. Beauty and awe were coupled with horror and suffering, inspiring us to attempt to make a better world through our actions.

How can I, an American citizen born twenty years after the dropping of the atomic bombs *Little Boy* on Hiroshima and *Fat Man* on Nagasaki, attempt to make art in response to Hiroshima? Like many, I have struggled with Adorno's claim that "to write poetry after Auschwitz is barbaric"[1] and Sebald's assertion that "...the construction of aesthetic or pseudo-aesthetic effects from the ruins of an annihilated world is a process depriving literature of its right to exist... The issue, then, is not to resolve, but to reveal the conflict."[2] Adorno and Sebald continued to write after Auschwitz and Hiroshima, inspiring many to fight, write, and make art against the barbarism of war. Working from *within* conflict to reveal it is what many artists do, exploring the clash between: representation and reality, genocide and humanity, beauty and the wreck of our world, truth and expression, form and content, meaning and feeling, visual pleasure and criticism, the "sailing vessel and the shipwreck."[3]

Later exposures to Hiroshima include seeing the film *Hiroshima mon amour*[4] in high school and reading John Berger's essay "The Sixth of August 1945: Hiroshima" in university. Berger speaks of Hiroshima as a calculated tragedy:

> The whole incredible problem begins with the need to reinsert those events of 6 August 1945 back into living consciousness...What happened on that day was, of course, neither the beginning nor the end of the act. It began months, years before, with the planning of the action, and the eventual final decision to drop two bombs on Japan. However much the world was shocked and surprised by the bomb dropped on Hiroshima, it has to be emphasized that it was not a miscalculation, an error, or the result (as can happen in war) of a situation deteriorating so rapidly that it gets out of hand. What happened was consciously and precisely planned...There was a preparation. And there was an aftermath.[5]

Another clear memory of Hiroshima involved my mother, who as a high school German teacher, had gone to Japan to teach English to schoolchildren. She traveled to Hiroshima and visited the Hiroshima Peace Memorial Museum where she bought a copy of Hiromi Tsuchida's *Hiroshima Collection*,[6] an unforgettable book of black and white photographs of artifacts from the museum's archive. Each object—a tattered school uniform, a deformed canteen, melted spectacles—is photographed in a field of white. The surfaces of the objects are like charred earth, topographies of destruction and loss. I asked my mother for that book and she gave it to me.

I did not know that I would end up in Hiroshima years later, in 2008, making images of the same objects from the Peace Museum's archive.[7] I placed these artifacts on cyanotype paper in bright sun and then rinsed them in the tub in the RERF apartment provided through my epidemiologist husband's research on the studies of atomic bomb survivors. (RERF, the Radiation Effects Research Foundation, originally the ABCC, Atomic Bomb Casualty Commission, was built by the U.S. Government in 1946 to study—*not treat*—the victims and survivors, and became a joint operation

with the Japanese in 1975.) I watched as white shadows of deformed bottles and leaves from A-bombed trees appeared in fields of indigo blue.

The history of the atomic age is intertwined with that of photography. Uranium's radioactivity was discovered through a photograph. In 1896, physicist Henri Becquerel placed uranium on a photographic plate to expose it to the sun. Because it was a cloudy day, he put the experiment in a drawer. The next day he developed the plate. To his amazement he saw the outline of the uranium on the plate that had never been exposed to light. He correctly concluded that uranium was spontaneously emitting a new kind of penetrating radiation and published a paper, "On the invis-

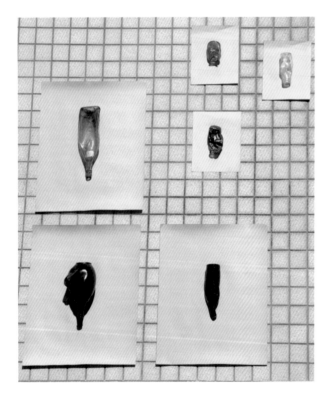

Exposing A-bombed bottles on cyanotype paper, Hiroshima, 2011.
Collection of the artist.

ible rays emitted by phosphorescent bodies."[8] *After Hiroshima* develops the relationship between radiation, aftermath, exposure, and the visual language of photography. Working with the staff at the Peace Museum, I utilized autoradiography (capturing radioactive emissions from objects on x-ray film), cyanotypes (natural sun exposures on cotton paper impregnated with cyanide salts), rubbings of A-bombed surfaces and subsequent photographic contact prints from the rubbings, and traditional photography to document places and objects that survived the atomic bombing. The autoradiographs involved placing A-bombed artifacts on x-ray film in light-tight bags for ten days. The lingering radiation in roof tile fragments, bamboo, and glass bottles, appears on the x-ray film much like Becquerel's uranium on photographic plates.

The cyanotypes are ghostly images of objects that survived the bombing, evoking those that vanished, much like the white shadows cast by incinerated people and bridge railings, ladders and plants at the time of the A-bomb.

The process and problem of *exposure* is central to my project. Countless people were exposed to the radiation of the atomic bomb. I expose already exposed A-bombed objects on x-ray film, but it is the radiation within them that causes the exposure. The cyanotypes of A-bombed artifacts render the traumatic objects as white shadows, atomic traces. The photographic contact prints of rubbings resemble x-rays, luminous negatives. It was critical to place the paper directly on the A-bombed surfaces and to rub a black wax crayon on the paper to make a "negative" imprint with which to make a "positive" photographic contact print. Tracing and touching the sites of survival, destruction, exposure, and history seem to capture an essence of the trauma, a residual radiation, a lingering energy of such a profound event. Akira Mizuta Lippit writes:

At Hiroshima, and then Nagasaki, a blinding flash vaporized entire bodies, leaving behind only *shadow* traces. The initial destruction was followed by waves of invisible radiation, which infiltrated the survivors' bodies imperceptibly. What began

as a spectacular attack ended as a form of violent invisibility...The 'shadows,' as they were called, are actually photograms, images formed by the direct exposure of objects on photographic surfaces. Photographic sculptures. True photographs, more photographic than photographic images.[9]

I am oddly elated and simultaneously disturbed by the alchemical appearance of the milky silhouettes of a round canteen, a slender hair comb with one tooth missing, and deformed glass bottles amid the deep and uneven cyan blue—fortunate to have had access to these materials in order to register them visually for others and bothered by the incalculable absence that these things mark and hold. Criminal absence has been made visibly present by itself. I am utilizing exposures to make visible the unseen, to reveal the denied or hidden results of military campaigns, scientific studies, and nuclear power. As an American exposing these already exposed objects, my intentions could not be more different than the pilot who dropped the bomb on Hiroshima. Kyo Maclear writes:

> We are, in the end, all mourners on this fragile earth, making daily choices about our participation (or lack thereof) in the fate of others who live, die, and grieve around us...Now that a half century has passed, what we see before us in places like Hiroshima and Nagasaki is a daily life from which most traces of trauma have been erased. Are there images that might be capable of piercing through our 'well-adjusted present'?[10]

As in my first book, *Bomb After Bomb: A Violent Cartography* (a series of drawings of places the U.S. has bombed), *After Hiroshima* engages ethical seeing, visually registers the aftermath of war and suffers the irreconcilable paradox of making visible the most barbaric as witness, artist, and viewer. As of 2007, there were over 250,000 *hibakusha* ("explosion-covered people," A-bomb survivors) in Japan, 78,000 still living in Hiroshima. Hibakusha Okada Emiko gave her harrowing account of survival as an eight-year-old

Still from the documentary film *The Effects of the Atomic Bomb on Hiroshima and Nagasaki*, produced by Akira Iwasaki and Nihon Eigasha (Nichiei, Japan Film Corporation), 1945. Photographed at the Hiroshima Peace Memorial Museum's daily screening by slavick.

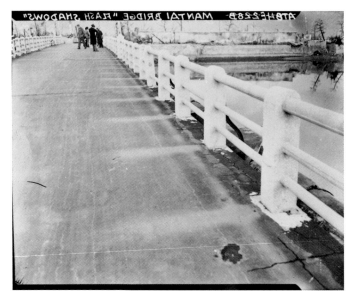

Yorozuyo Bridge (also known as Mantai), "Flash Shadows," Taken by the U.S. Army after the war. Black and white photograph of white/negative shadows of bridge railing, Hiroshima Peace Memorial Museum

Lingering Radiation, silver gelatin contact print of an x-ray autoradiograph of an A-bombed tree stump from the Hiroshima Peace Memorial Museum archive, 2008. Collection of the artist.

girl. She concluded, "There are now over 30,000 nuclear weapons in this world. Hiroshima and Nagasaki are not past events. They are about today's situation."[11]

Every year there is an August 6. Since being in Hiroshima, I now remember: my children kissing A-bombed trees and saying *sorry*; the heaps of garlands of paper cranes left at memorials and historically significant sites; flying into Hiroshima and not quite believing how lush and green the surrounding mountains were; feeling as if I were on fire as I walked, touched, rubbed, exposed, collected, photographed, ate, and mourned Hiroshima.

A NOTE ON AFTER

After Hiroshima is made *after* the poetry that should never have been written after the holocaust; *after* everything that has been said and done in response to Hiroshima; *not* in imitation of; *not* in a post-modern sense of appropriation or beyond; in honor of Hiroshima and the people who disappeared and survived; against forgetting; as evidence, traces of the aftermath. There is no way to be in the before time before Hiroshima.

In translating the title *After Hiroshima* into Japanese, I am struck by the complexity of choosing the Japanese script for the word *Hiroshima*. Should I use the pre-bombing kanji or the post-bombing kanji or the katakana, or haranga? How to include all of Hiroshima—the before and after, and the present? Translating *After* was no easier. There are several Japanese words for *After* and each one can be written in the aforementioned scripts, each of which has a different aesthetic, emotional weight and conceptual meaning. After much debate, *Hiroshima* is in katakana and *After* ("sono ato") is in hiragana. Translator Kyoko Selden explains, "Katakana is preferred when meaning Hiroshima (or Fukushima) as a social, historical, ethical issue that encompasses a broad spectrum of experiences inside and outside the area. The katakana form is at once abstract, all-inclusive, deliberately devoid of, or beyond, geographical senses, and, here, specific to nuclear power as

a human concern." According to Sylvia Watanabe, "Hiroshima spelled out in katakana signifies A-bombed Hiroshima as a modern phenomenon, having been made somewhere else and introduced into Japanese culture; of the isolation and sequestering of the victims; of Hiroshima's other identity as the city of peace, a symbol of remembrance—until we do, finally, attain peace."[12] Until we make what has disappeared appear.

ENDNOTES

For full citations, see Sources list on page 112.

1 "Even the most extreme consciousness of doom threatens to degenerate into idle chatter. Cultural criticism finds itself faced with the final stage of the dialectic of culture and barbarism. To write poetry after Auschwitz is barbaric. And this corrodes even the knowledge of why it has become impossible to write poetry today." Adorno, "Cultural Criticism and Society," 34.

2 Sebald, *On the Natural History of Destruction*, 53 and 158.

3 "To invent the sailing vessel or the steam ship is to *invent the shipwreck*." Virilio, *Unknown Quantity*, 24.

4 *Hiroshima mon amour*, film, 1959, directed by Alain Resnais, screenplay by Marguerite Duras. This film opens with footage from Akira Iwasaki's traumatic documentary film *Hiroshima-Nagasaki, August, 1945*.

5 Berger, *The Sense of Sight*, 287 and 295.

6 Tsuchida, *Hiroshima Collection*. Tsuchida published two other books on Hiroshima, *Monument* and *Monument II* that feature places and buildings close to the epicenter. In *Monument II* (1995) Tsuchida returned to Hiroshima to re-photograph places he had shot in the 1970s, from the exact same vantage point. These are placed side by side on opposite pages.

7 Coincidentally, while I was in Hiroshima, Miyako's extraordinary exhibition, *HIROSHIMA Strings of Time*, was at Hiroshima City Museum of Contemporary Art. Miyako photographed the same artifacts (choosing those that were once against human skin) against an illuminated white background in full color. She writes about the artifacts, "The objects that remained in the city after being subjected to a military and scientific experiment do not speak, they merely exist, but despite the horrors of the details, I found myself overwhelmed by the bright colors and textures of these high-quality clothes. It is difficult for a human being to survive for even one hundred years, but these objects have been bestowed with a longer existence. As part of the largest scar the world has known, they will outlive us all, and never grow old." Miyako, *Hiroshima*, 76.

8 Becquerel, "Sur les radiations émises par phosphorescence," 501.

9 Lippit, *Atomic Light (Shadow Optics)*, 86 and 94.

10 Maclear, *Beclouded Visions*, 134 and 137.

11 Okada Emiko gave her account to a handful of people at the Hiroshima National Peace Memorial Hall for the Atomic Bomb Victims in 2008.

12 Sylvia Watanabe in a personal email to the author, 2012.

ヒロシマ・そのあと

エリン・オハラ・スラヴィック

ヒロシマのことで最初に覚えているのは、１９７０年代のいつであったか、生まれ育った町メイン州ポートランドの記念公園で８月６日の「ヒロシマの日」に、両親と立っていたときのことだ。父が何かを話した。母が話した。私も、話をしてみた。私の選んだ話題は、少女の時に被爆した女性の体験談だった。私はそれをやっとの思いで読んだ。皮膚が溶け、蛆が頭に湧き、母を失い、父を失い、見馴れた世界が消えてしまった、というその女性の記憶に、声が途切れそうになった。

私は7人兄弟の末っ子だが、私たちは皆、両親からこう教えられた。ひもじい子供たちがいることを考え、与えられた食べ物は残さずに食べること。農民の権利を支持するセザール・チャヴェズを応援し、ガロのワインはじめブドウやレタスをボイコットすること。世界で起こっていることを知り、戦争、不平等、不正、飢え、貪欲などを嘆くこと。

母がドイツ国籍のため、両親は私たちをたびたびヨーロッパに連れて行った。母はシュトゥットガルトに育ち、子どものとき、不発弾がベッドに落ちたが、叔母がちり取りで窓の外に投げ捨てた。母が第二次世界大戦を生き延びたのは、両親がコッヘルスタインスフェルトという小さな町に家族を移したためである。父母は私たちに華麗な教会や美しい田園を見せ、開いてさえいればどの美術館にでも連れてゆき、そのうえ、ダハウ収容所にも連れて行った。美と畏敬が恐怖と苦しみに連なり、行動を通してより良い世界を作ろうという気持ちを養った。

広島と長崎へそれぞれ原子爆弾リトルボーイとファットマンを投下してから２０年後に生まれたアメリカの一市民である私は、どのようにしてヒロシマに反応する美術作品を作ることができるのか。大勢の人々と同じく、私も、「アウシュヴィッツのあとで詩を書くことは野蛮だ」[1]というアドルノの主張に悩んだ。ゼーバルトは「壊滅した世界の廃墟から美的あるいは疑似美的な効果を構築することは、文学を、その生存権を、剥奪する過程である……だとすれば問題は、葛藤を解決することではなく、それを明示することだ」[2]と述べた。アドルノとゼーバルトは、アウシュヴィッツとヒロシマのあとにも著作を続けた。それに触発されて戦争の野蛮さに抗して戦い、ものを書き、美術活動をした人も多い。葛藤の内側からそれを表面化するために仕事をするのは、多くの美術家のすることであり、彼らは概念と現実、大量殺戮と人道、我々の世界の美と破壊、真実と表現、形と内容、意味と感情、視覚的楽しみと批評、「帆走船と難破」[3]といったもののぶつかり合いを探求している。

その後ヒロシマに触れた経験の中には、高校で映画「二十四時間の情事」(ヒロシマ・モンアムール)を観たことと、大学でジョーン・バージャーの随筆「広島、1945年八月六日」[4]を読んだことが含まれる。バージャーはヒロシマを計算された悲劇だとする。

> 信じられないほどの問題全体が、１９４５年８月６日の出来事を生の意識の中に再び組み入れる必要から始まる……その日起こったことは、言うまでもなく、原爆投下行為の始まりでも終わりでもない。何ヶ月も、何年も前に、行動計画をもって、そして日本に二発の爆弾を落とすという最終決定をもって、それは始まったのだ。広島に投下された爆弾によって世界がどのように衝撃を受け驚いたとしても、強調せねばならないのは、それが計算違いでもなければ間違いでもなく、また、(戦争にはありかねないことだが)状況が急速に悪化して手の施しようがなくなった結果でもないということだ。起こったことは、意識的にかつ精密に計画された……準備があった。そしてその結果があった。[5]

ヒロシマについてもう一つはっきり覚えているのは、母にかかわることだ。母はハイスクールのドイツ語教師であったが、小学生に英語を教えるため、日本に行ったことがある。そのおり広島へ旅をし、広島平和記念館を訪れ、土田ヒロミの『広島写真集』[6]を買った。平和記念館の保管物から選んで撮影した、忘れ得ぬ白黒の写真集である。ぼろぼろになった学童服、歪んだ水筒、溶けた眼鏡など、それぞれの対象が白を背景に写されている。それらの被写体の表面は焼け焦げた大地のようであり、破壊と喪失の地勢図のようであった。母に頼んで、私はその写真集をもらい受けた。

その時は予想もしなかったことだが、何年も経って２００８年に私は広島に行き、平和記念館のその同じ被写体のイメージを作成することになった。[7] 私はこれらのオブジェを明るい陽光の中で青写真(シアノタイプ)紙の上に置き、そのあと湯船の中ですすいだ。場所は放射線影響研究所(REFE) のアパート

で、それは疫学者である夫が被爆者研究の調査を行う関連で提供された。(放射線影響研究所は、もともとは原爆障害調査委員会、略してABCCと言い、1945年アメリカ政府により死者と生存者を、治療するためにではなく調査するために設立され、1974年に日本との共同運営となった。) 私は、ゆがんだ瓶や被爆した木の葉の白い影が紺色の地に現れてくるのを見つめた。

原子時代の歴史は写真術の歴史と織り合わさっている。ウラニウムの放射能は一枚の写真を通じて発見された。1896年物理学者アンリ・ベクレルは、ウラン塩を写真乾板の上に置いて陽光にさらそうとした。ところがその日は曇り日であったので、その実験材料を引き出しにしまった。翌日、写真乾板を現像したのだが、驚いたことに、光を当てもしなかった乾板の上にウラン塩の輪郭が見えた。ウラニウムは自然発生的に新しい種類の浸透性をもつ放射線を出している、と正しく結論し、ベクレルは「燐光性物体によって放射される目に見えない光線について」という論文を発表した。[8]『ヒロシマ、そのあと』は、放射線、痛手、被曝、視覚的言語たる写真、などのあいだの関係を照らし出す。平和記念資料館館員の協力を得て、オートラジオグラフィー(放射性物質から放出される放射線をX線フィルム上にとらえる手法)、青写真(シアン化物を含ませた木綿紙に天然の太陽光を当てて感光させる)、被爆した表面をこすって得たものやそれからの密着印画、伝統的写真、などを使って原爆後に残った場所や物件を記録した。オートラジオグラフの場合は、被爆した物件をX線フィルム上にのせて、光を通さない袋に入れ、10日間保存した。屋根瓦の破片、竹、ガラス瓶などに残存する放射線は、ベクレルの写真乾板上のウラン塩とほぼ同様の現れ方をする。

これら青写真は原爆生存物の陰陰たる画像であって、消滅した存在を喚起することは、原爆炸裂時に灰と化した人々や、橋の欄干、梯子、草木などの投じた白い影と同様である。

光に物体をさらす過程と問題は、私の制作課題にとっては中心的である。無数の人々が原爆の放射線にさらされた。私はすでにさらされた被爆オブジェをX線フィルムにさらすのだが、その露光をもたらすのは被爆オブジェの内部にある放射線である。被爆した事物の青写真は、それら悪夢的なオブジェを白い影として、原子力の傷跡として示す。表面を擦って拓本した密着印画はレントゲン写真の光る陰画に似ている。紙を直接被爆した物体の表面に当て、黒色の蝋クレヨンを紙にこすりつけ、「陰画」のインプリントを作ることはきわめて重要であった。そこから、「陽画」の密着写真映像を作るのだ。生存、破壊、露光、歴史の跡を辿り、それに触れることは、トラウマの本質を、残余の放射線を、かくも深刻な事件のなおも残存するエネルギーを、捉えることのようであった。アキラ・ミズタ・リピットは次のように書いている。

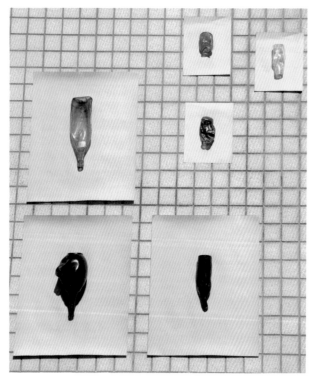

被爆した瓶を青写真紙上に露光、広島、2011年
作者所蔵

> 広島で、そして長崎で、眼もくらむ閃光が人々の全身を蒸発させ、影の跡をのみ残した。当初の破壊の次に来たのは、眼に見えない放射線の波であった。それは生存者の体をいつのまにか侵していった。壮絶な攻撃として始まったものは、結果として、暴力的な不可視性という形を取った……。それら「影」と呼ばれたもの

は、実際にはフォトグラム、すなわち印画紙の表面に直接物体を置いてできた映像である。光照射による彫刻。写真という光映像よりもさらに写真的な、真の光映像。[9]

深い、まだらな青の中で、丸い水筒や歯の一本抜けた細い櫛や変形したガラス瓶などの乳白色の影絵が、錬金術的に現れるのを見ると、私は不思議と昂揚もし、同時に心を乱される。これらの物品を視覚的に捉えて人々に見てもらうため使用できるのは幸運ではあるが、これらに刻印され保存された、計り知れぬ不在に惑うのだ。犯罪的な不在はそれ自体、目に明らかなものとされてきた。私は感光した印画を用いて見えないものを見えるようにし、軍事行動や科学的研究や原子力の否定あるいは隠蔽された結果を露見させる。すでに光照射されたこれらの物体を光照射する——アメリカ人として、私の意図は、広島に爆弾を投下した操縦士とはまったく異なる。キョー・マックリアは言う。

　　終局的には、私たちは皆、このもろい大地の上での弔い人であり、身のまわりで生き、死に、そして嘆く他人の運命へのかかわり（あるいはかかわりをもたないいこと）について日々、選択をしている……。半世紀を過ぎた今、広島や長崎のような場所で目前にするのは、トラウマの跡がほぼ消された日常生活である。＜順応した現今＞を貫くような画像というものはありうるのだろうか[10]

私の最初の本、『爆弾、また爆弾——暴力の地図作り』（米国の爆撃した場所を複数の絵で表したもの）と同じように、『ヒロシマ、そのあと』は、戦争の痕跡を倫理的に見、視覚的にとらえ、最大に野蛮なものを証言者・美術家・観察者として視覚化することの調和不可能なパラドックスに苦しむ。2007年現在、25万人の被爆者がいた。これは原爆被爆生存者の数で、そのうち7万8千人が今でも広島に住んでいる。被爆者の岡田恵美子は8歳の時のすさまじい生存記録を語り、こう結ぶ。「いま、3万以上の核兵器がこの世に存在します。広島と長崎は過去の出来事ではありません。今日の状況なのです」[11]

毎年一度、8月6日はやって来る。広島に滞在してから、今思い出すのは、私の子供たちが被爆した木にキスをして　ごめんね　と言ったこと。記念碑や歴史的に重要な場所に千羽鶴が幾重となく幾束となく捧げられていたこと。広島へ向かう飛

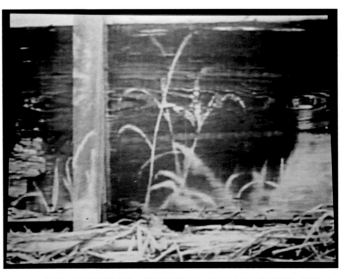

1945年岩崎昶・日本映画社制作の記録映画『広島・長崎における原子爆弾の影響』より、スチール写真。広島平和記念資料館の毎日の上映においてエリン・オハラ・スラヴィック撮影

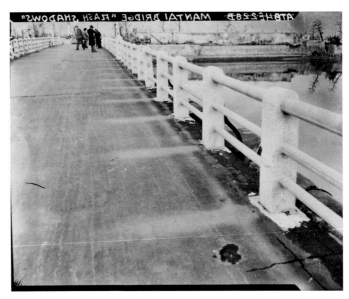

「万代橋の熱線影」戦後米軍撮影、欄干の白／陰画をとらえた白黒写真
広島平和記念資料館

「残存放射能」広島平和記念資料館記録保管室所在の被爆した切り株を
X線オートラジオグラフ処理した銀−ゼラチン密着印画、2008年
作者所蔵

行機の中で、周りの山々がいかにもみずみずしく青くて信じがたく思ったこと。体が焼けこげるような気持ちで歩き、触れ、擦り、光にさらし、集め、写真に撮り、ものを食べ、広島を悼んだこと。

「そのあと」について

『ヒロシマ・そのあと』が作られたのは、ホロコーストのあとでは書かれるべきではなかった詩の「あと」であり、ヒロシマを受けてすべてが語られ、なされた「あと」である。「に倣って」ではなく、「を応用して」とか「を越えて」というポストモダンの意味ででもない。広島と、消え去りあるいは生き残った人々とに敬意を表して、あとに残されたものの証拠・痕跡として、である。ヒロシマ以前の「前の時間」に存在することは絶対にできない。

After Hiroshimaという英語題名を日本語に移す段で、私はHiroshimaという語の日本文字を選ぶことの複雑さに打たれた。当用漢字表採択以前の廣島という漢字を使うべきか、採択後の広島がよいか、カタカナにするか、それともひらがなにするか。どうしたら、爆撃以前、爆撃以後、そして現在の広島を含めることができるか。Afterを訳すのも、容易ではなかった。Afterを意味する日本語はいくつかあり、しかもそれぞれ漢字、カタカナ、ひらがなで表記できる。どの表記もそれぞれ異なる美的・情緒的重さと観念的な意味を持つ。いろいろ考えた末、Hiroshimaはカタカナ、After（そのあと）はひらがなとした。訳者のセルデン恭子は、「Hiroshima（Fukushimaの場合もです）がその地域内外での広い枠の経験を含む社会・歴史・倫理的な問題を意味するときには、カタカナが優先されます。カタカナ表記は抽象的・包括的であり、地理的限定を意図的にいったん離れ、あるいは越えることをしますが、とくにこの場合は、人間の関心事としての核力につながるものと思います」と説明する。シルヴィア・ワタナベによれば、カタカナつづりのヒロシマは、日本以外で作られて日本文化に入ってきた現代の現象としての被爆した広島を意味する。それは、被爆者たちの孤立と隔離、また、平和の都市であり記憶の象徴としての広島のもう一つの顔を意味する、終に私たちが平和を達成するまでは」[12]私たちが消え去ったものの姿を現れるようにするまでは。

ENDNOTES

詳しくは112ページの出典項目を参照。

1　テオドール・アドルノ『プリズム、文化批評と社会』1949年。「最も極端な運命意識でさえ、無駄話に堕しかねない。文化批評は、文明と野蛮の弁証法の最後の段階と向かい合ってしまう。アウシュヴィッツのあとで詩を書くことは野蛮である。そしてこれは今日なぜ詩を書くことが不可能になったのかという知識をさえ浸食する。

2　WGゼーバルト『破壊の自然史』ニューヨーク、ランダムハウス、2004年

3　「帆走船や蒸気船を発明することは、難破を発明することだ」ヴィリリオ『未知の量』ニューヨーク、テムズ＆ハドソン、24ページ。

4　アラン・レネ監督、マルグリット・デュラス脚本『二十四時間の情事』(ヒロシマ・モン・アムール)、1959年。英訳はリチャード・シーヴァー、ニューヨーク、1961年、和訳には清岡卓行訳『ヒロシマ、私の恋人』ちくま文庫1990年(初版は筑摩書房1970年、阪上脩訳「かくも長き不在」を含む)。この映画は岩崎昶の悪夢的ドキュメンタリー映画『広島・長崎、1945年八月』からの映像で始まる。

5　ジョーン・バージャー『視覚』(The Sense of Sight) ニューヨーク、ヴィンテッジインターナショナル、1985年、287-95ページ。

6　土田ヒロミ『広島集』日本放送協会、1995年。土田はこのほか広島につい二冊、爆心地に近い場所や建物を中心とする作品『モニュメント』『モニュメントII』を発表している。『モニュメントII』において土田は広島に戻り、1970年に撮影した場所を、全く同じ視点から再び撮影した。これらの写真は左右のページに置かれている。

7　偶然私が広島滞在中に、石内都の非凡な展示「ヒロシマ　時間の糸」が広島市現代美術館で開かれた。石内都は同じ物件を(かつて人間の皮膚に接触していたものを選び)照明された白い地を背景にカラーで撮影した。それらの物品について彼女は書く「軍事的・科学的実験に晒されたあと、広島市に残ったものは、みずから語らない、たんに存在する。しかし恐ろしい具体的事情にもかかわらず、上等な衣服の明るい色彩と風合いに私は驚かされた。人間は100歳以上まで生きるのは難しいが、これらの物品はその存在を与えられている。世界が知った最大の傷の一部として、それらは私たちみなよりも永く生き、年老いることもないだろう」(石内美也子『ヒロシマ』東京、集英社2008年。

8　アンリ・ベクレル、フランスの科学誌『コント・ランデュ』(Comptes rendus de l'Académie des sciences) 122, 501, 1896年。英訳はカルメン・ジウンタ。

9　アキラ・ミズタ・リピット『原子の光(影の光学)』ミネソタ大学出版局2005年、86ページおよび94ページ。

10　キョー・マクリア『曇った視野――広島長崎と目撃の芸術』(Beclouded Visions: Hiroshima and Nagasaki and the Art of Witness) ニューヨーク州立大学出版局、1999年、134ページおよび137ページ。

11　岡田恵美子は広島国立平和記念ホールで2008年に少数の人々を対象に話をした。

12　シルヴィア・ワタナベより著者への個人的な電子メイル、2012年。

Cyanotypes of A-bombed Artifacts
from the Hiroshima Peace Memorial Museum Archive
and A-bombed Trees in Hiroshima,
2008-2011:

青写真
広島平和記念資料館アーカイヴの被爆物
および広島の被爆した木々:

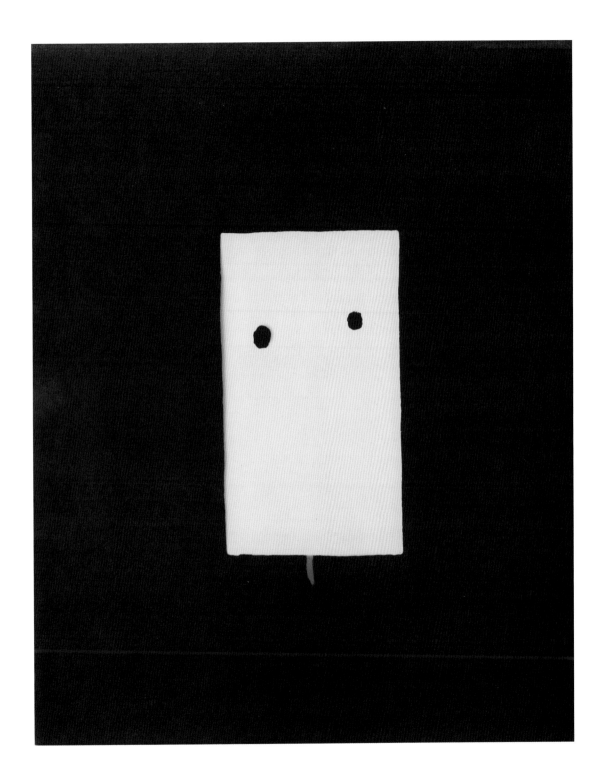

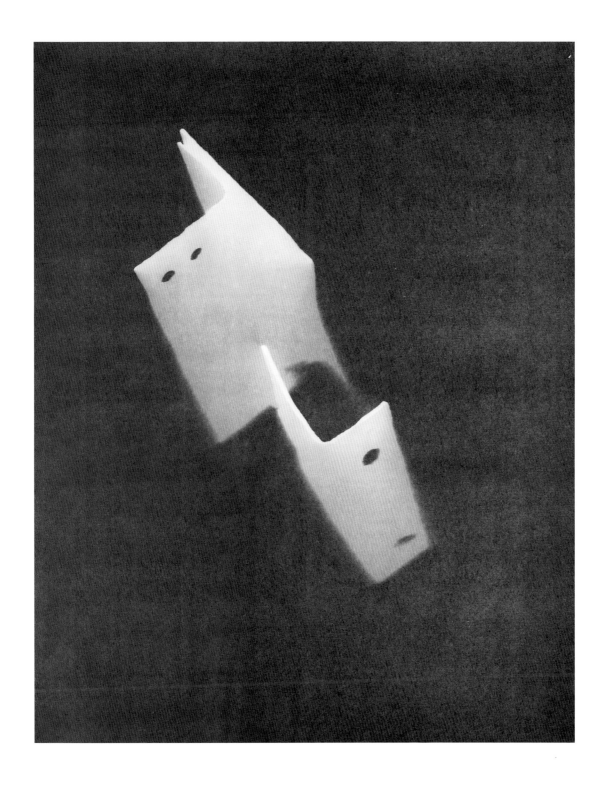

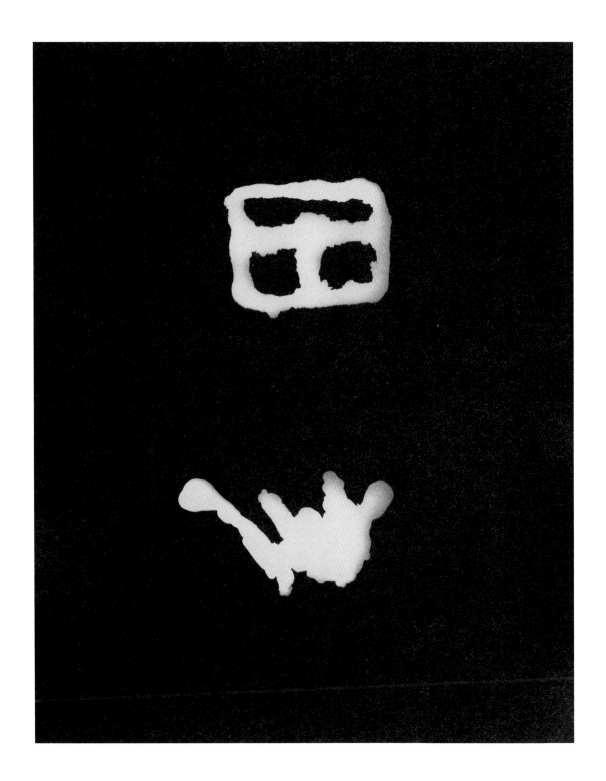

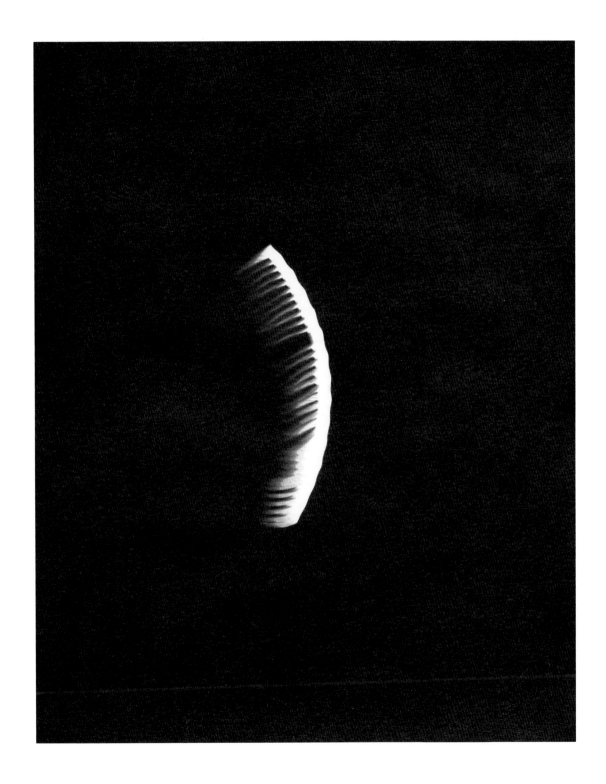

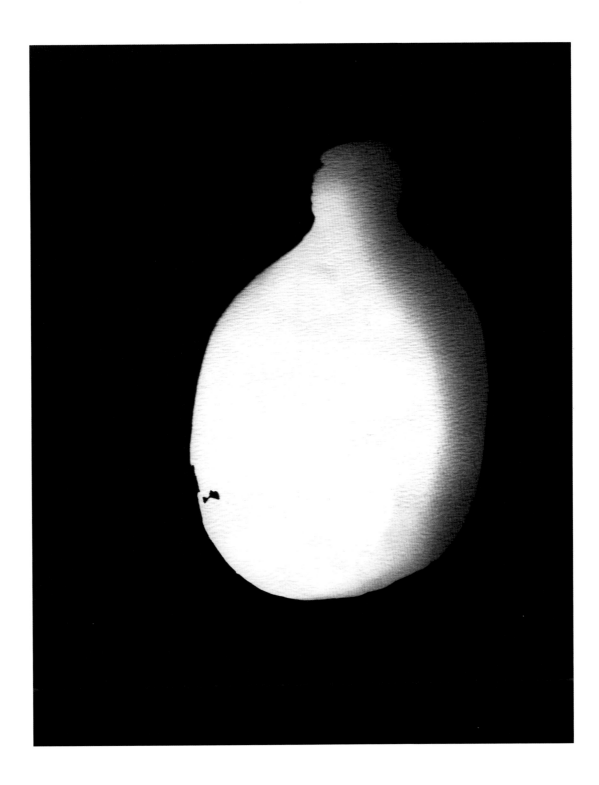

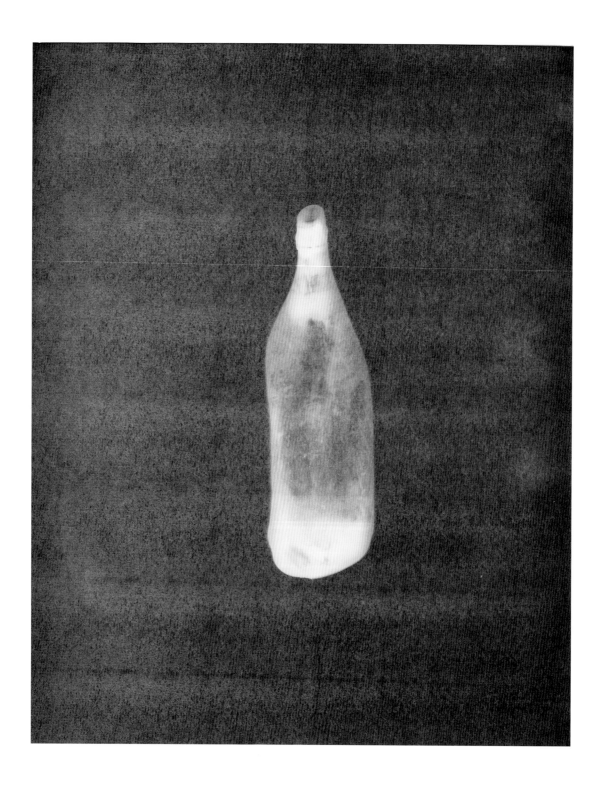

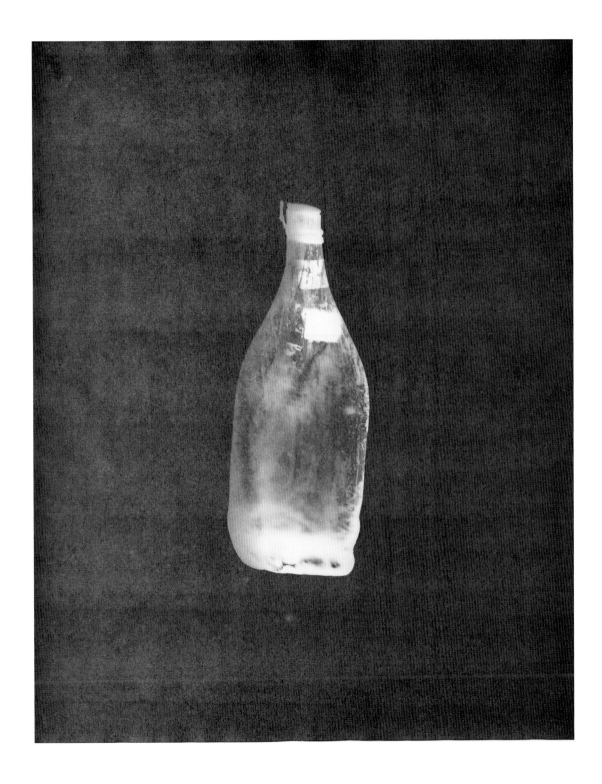

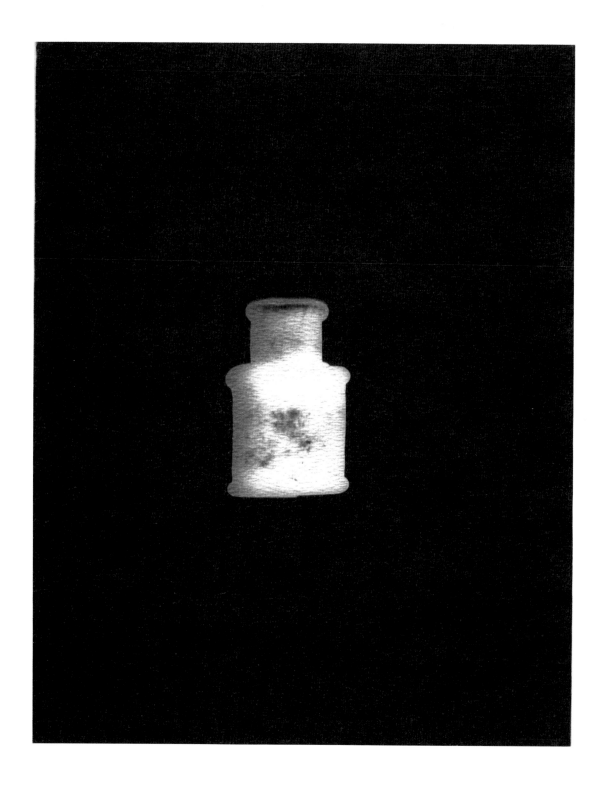

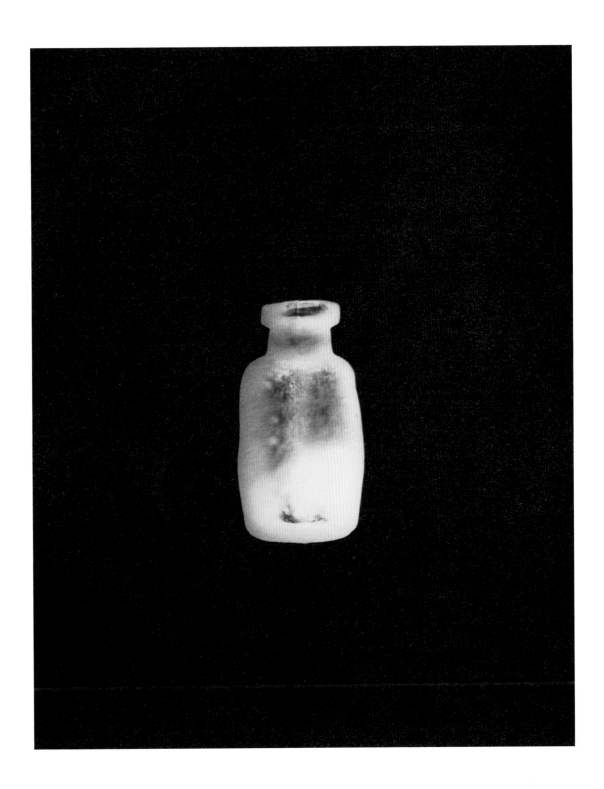

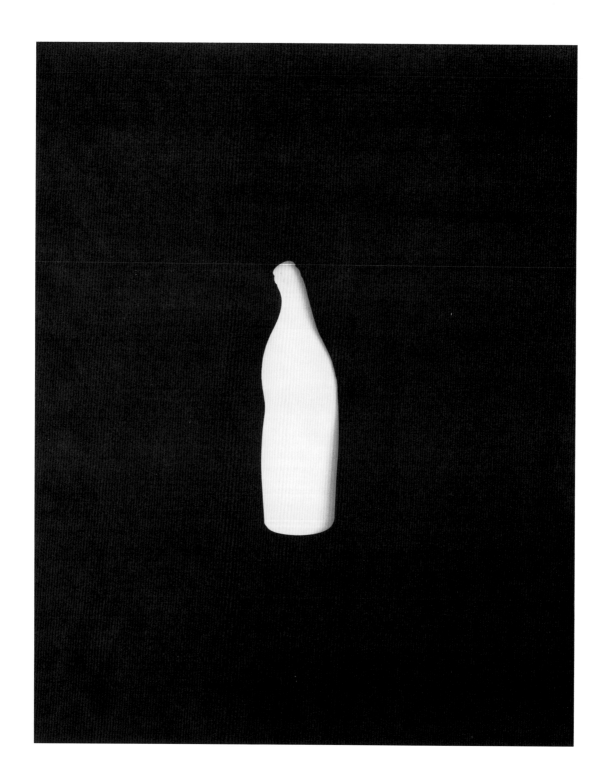

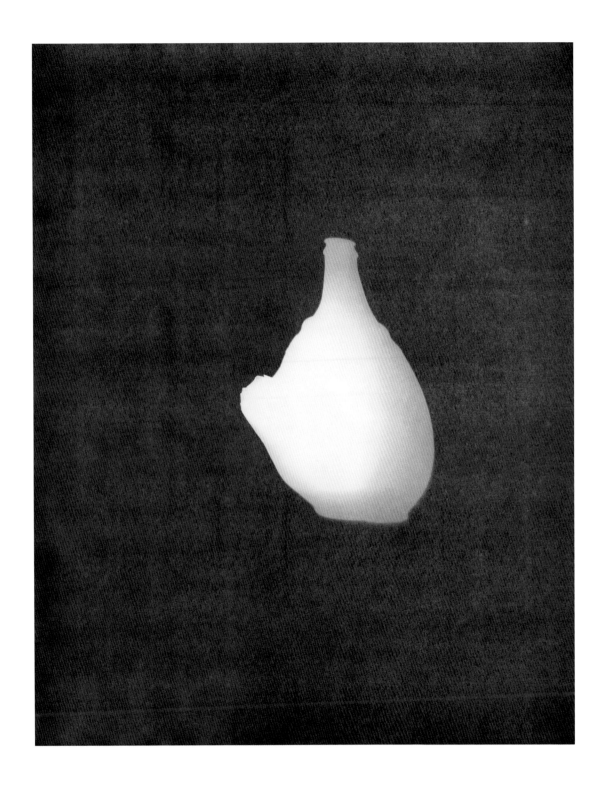

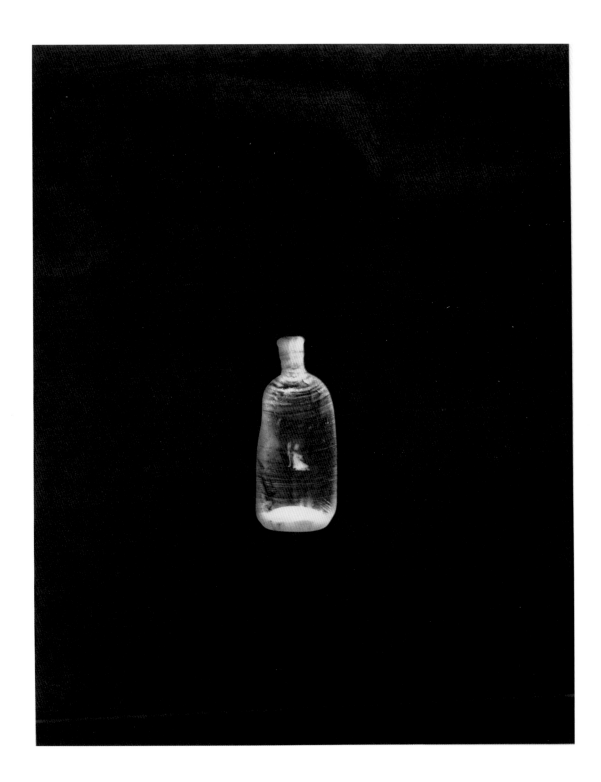

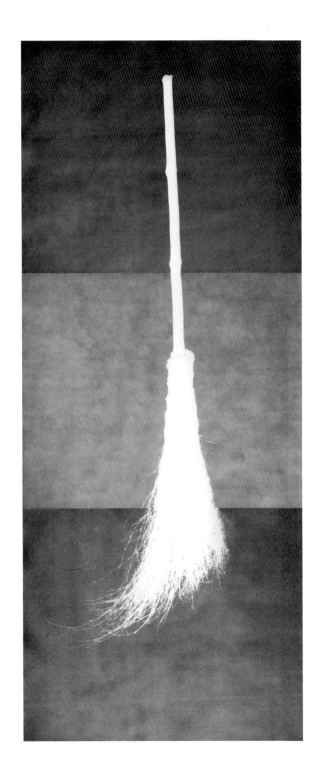

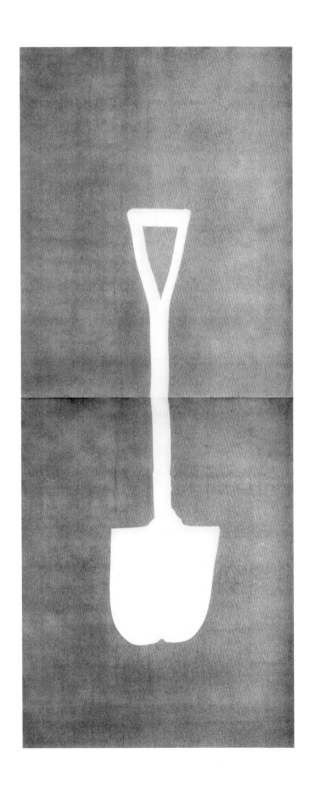

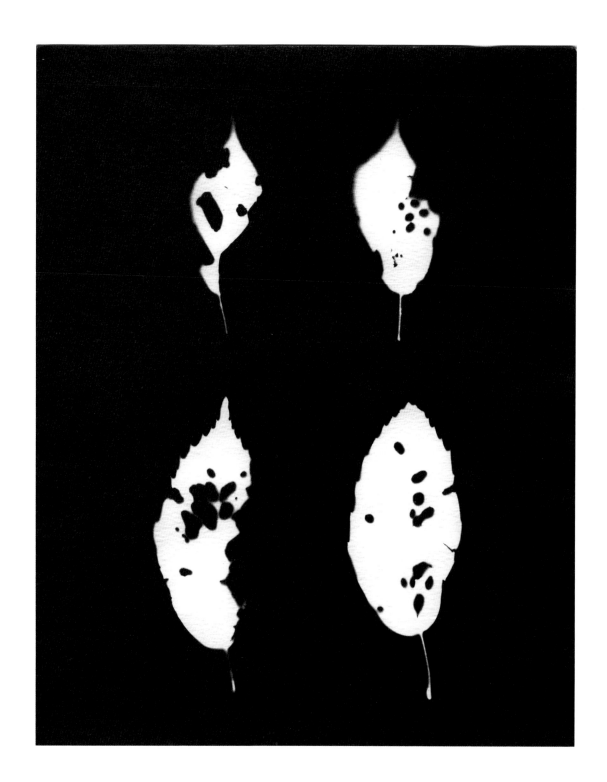

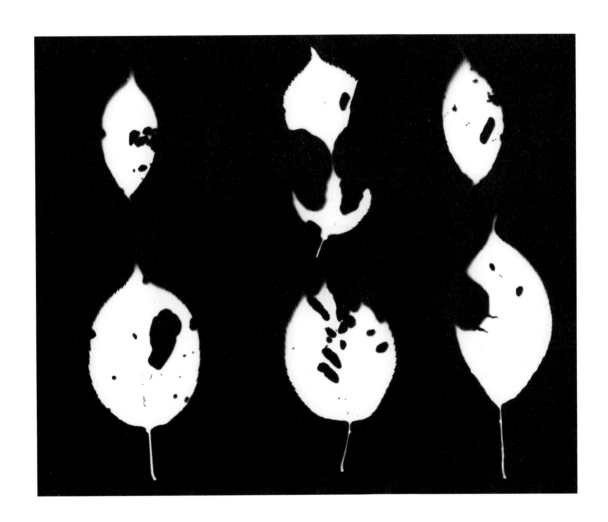

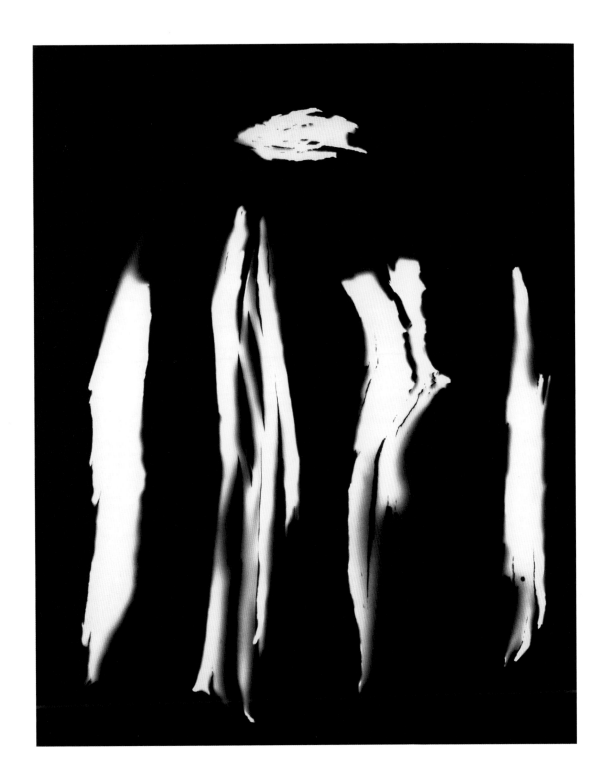

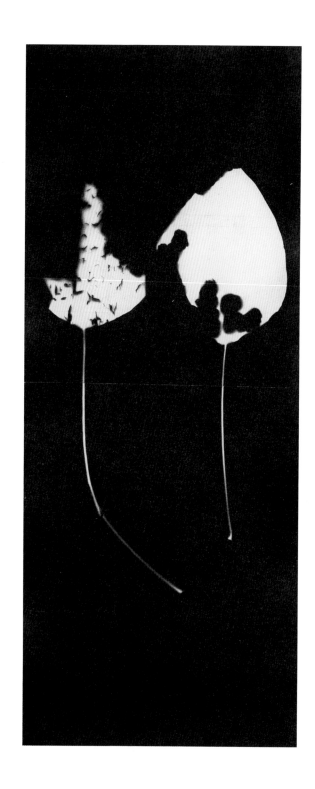

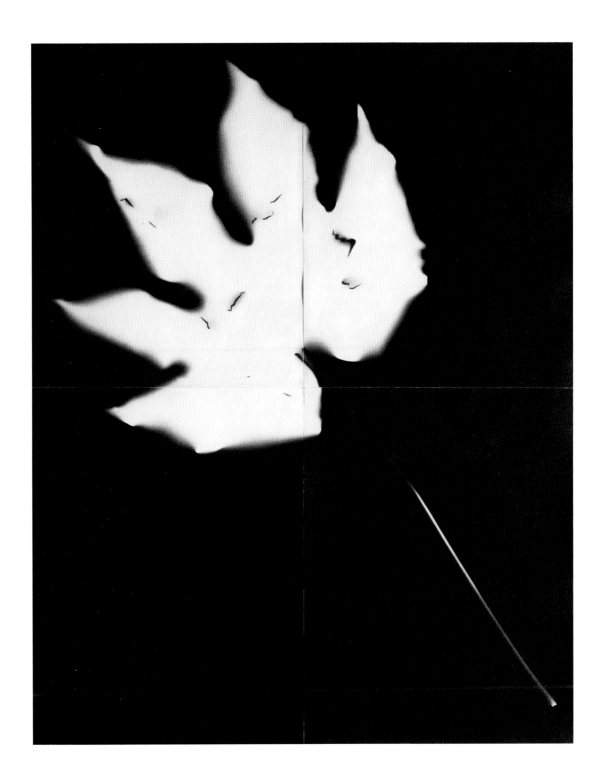

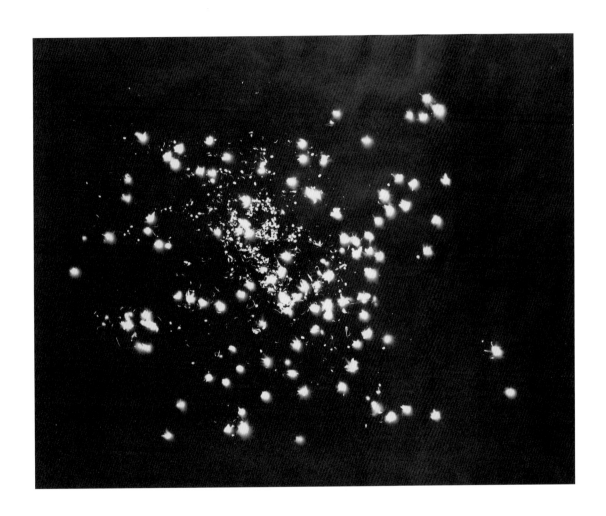

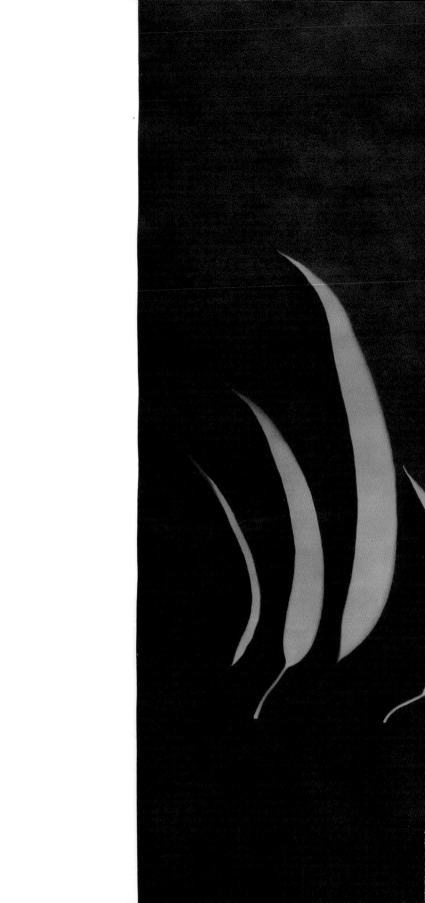

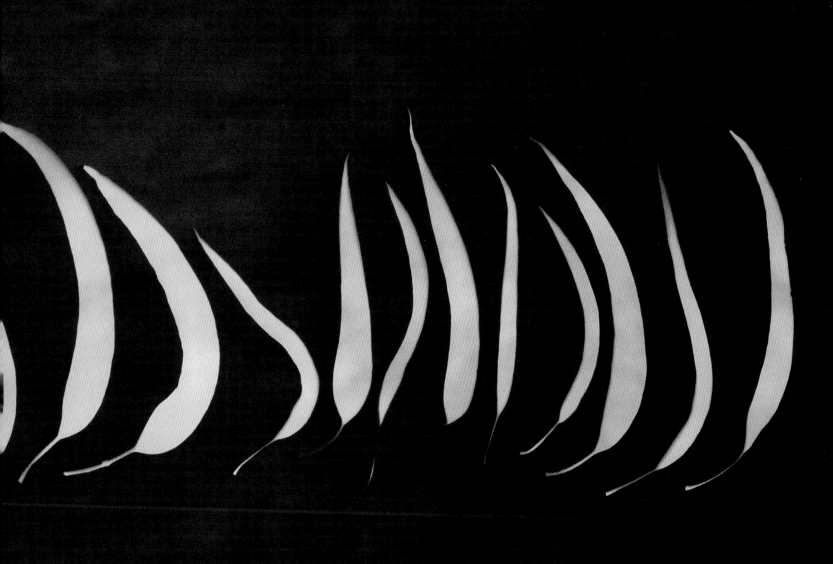

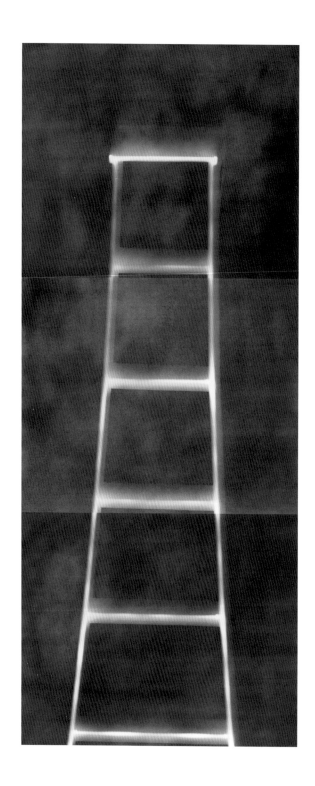

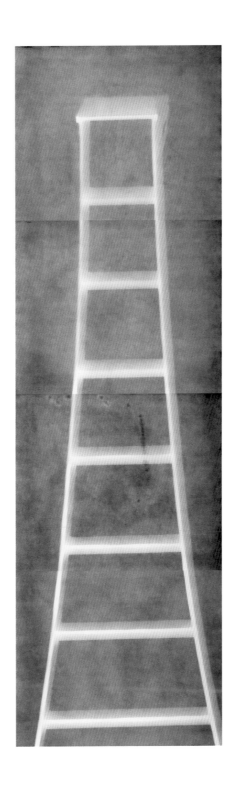

Silver Gelatin / Photographic Contact Prints
of Rubbings from A-bombed Surfaces in Hiroshima,
2008:

銀−ゼラチン／コンタクトプリント
広島の被爆物表面の拓本:

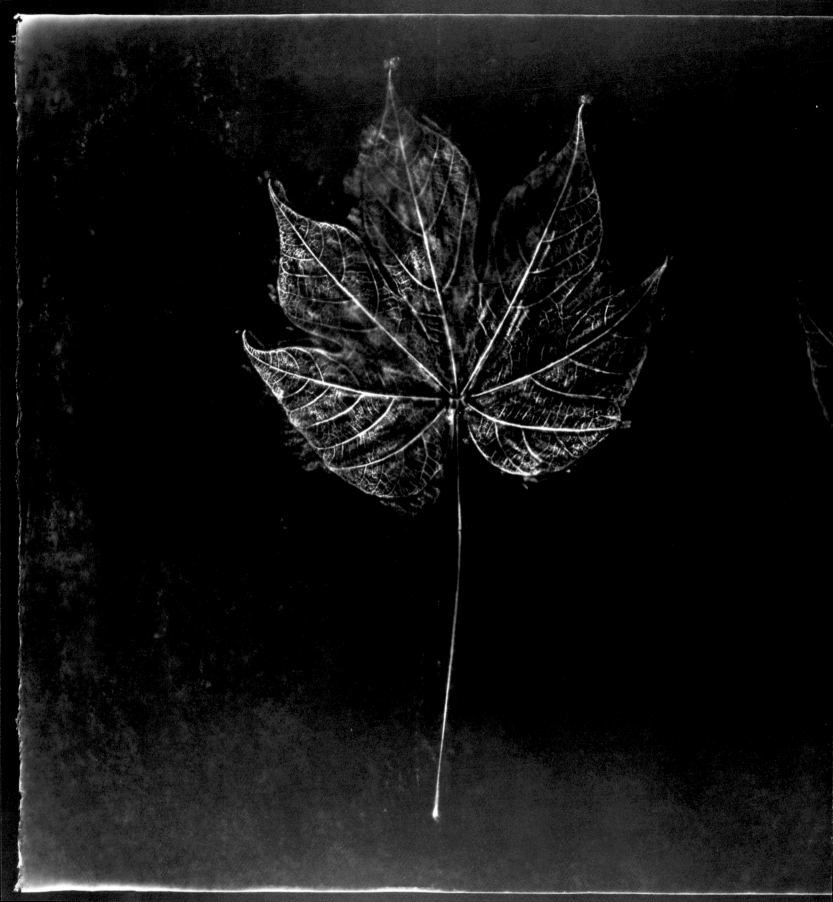

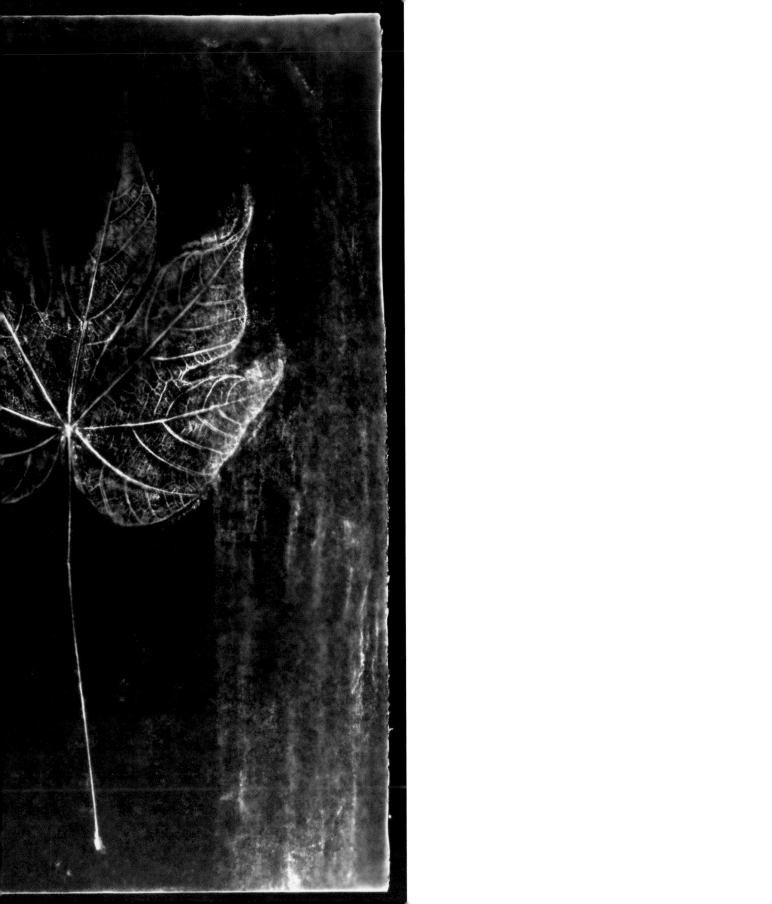

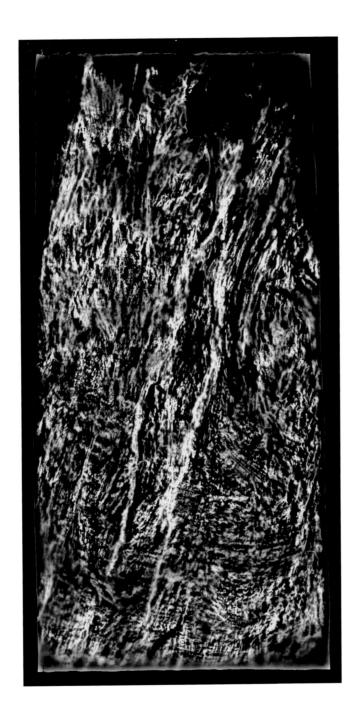

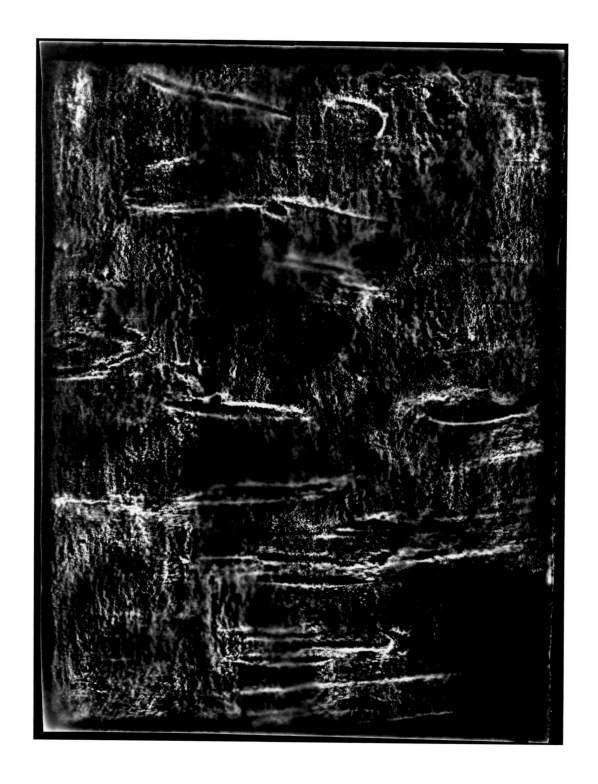

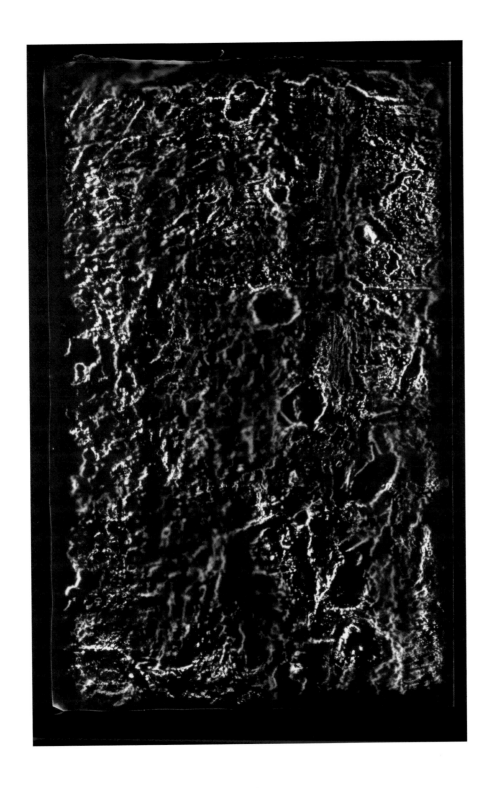

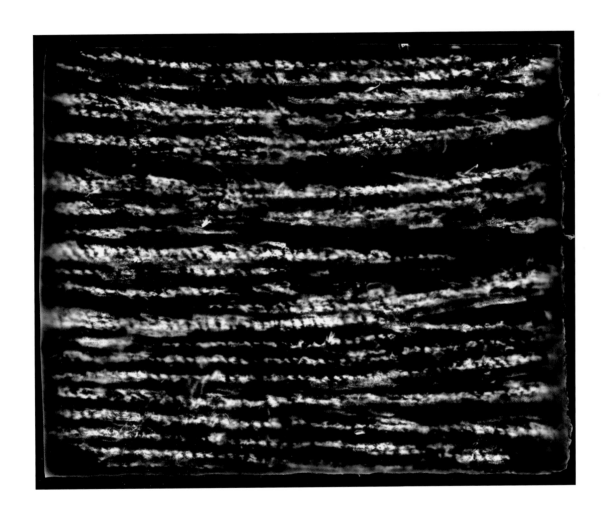

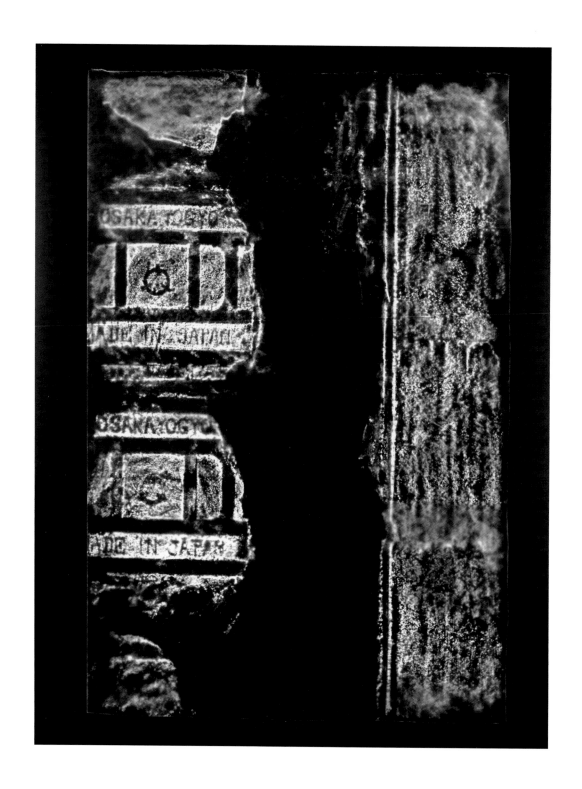

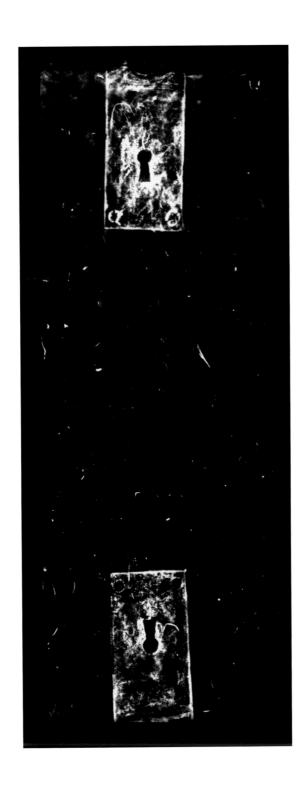

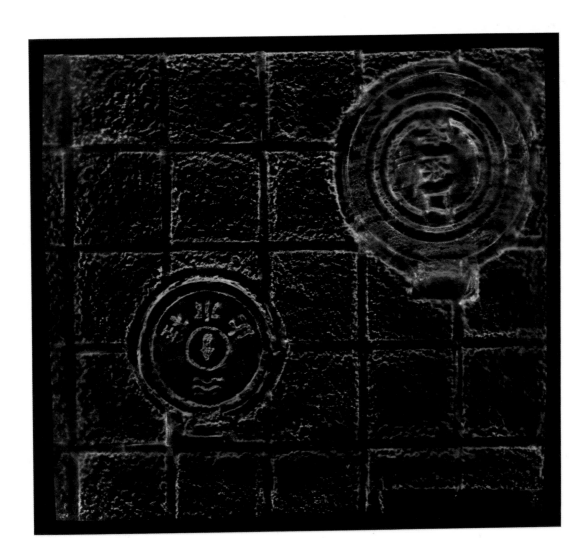

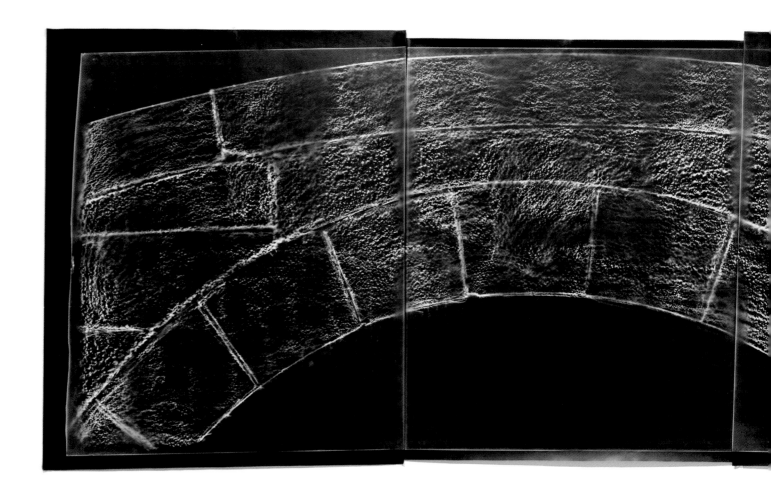

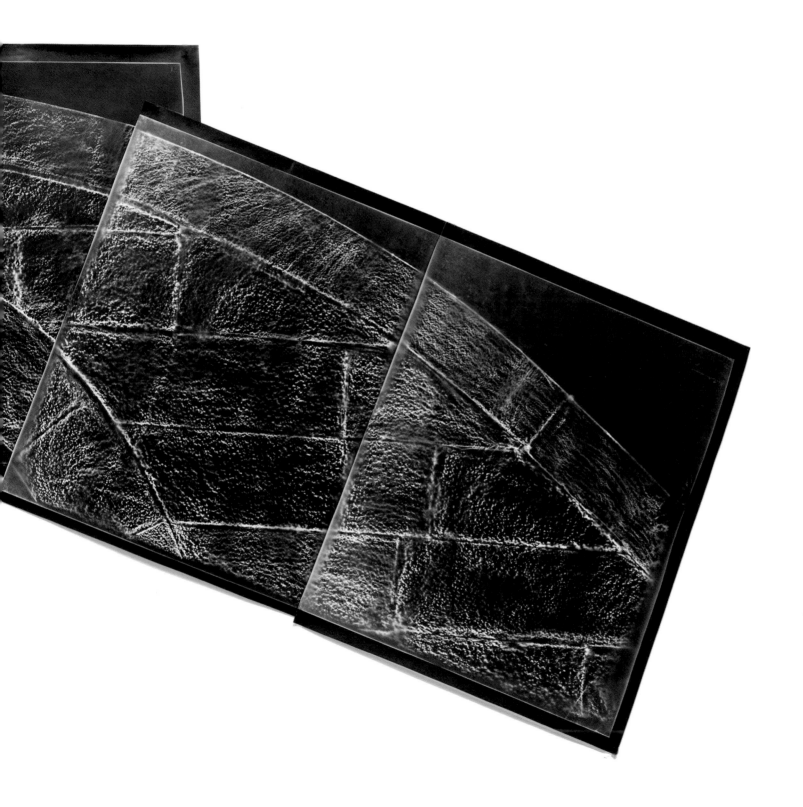

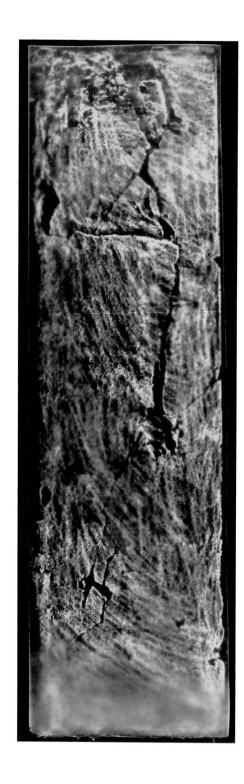

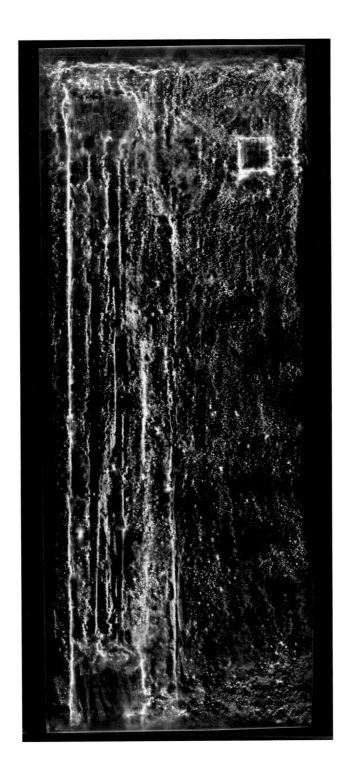

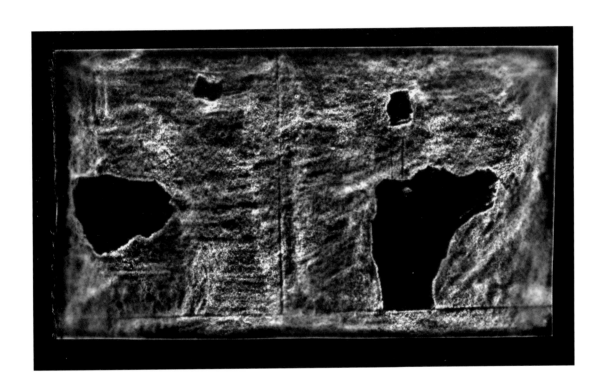

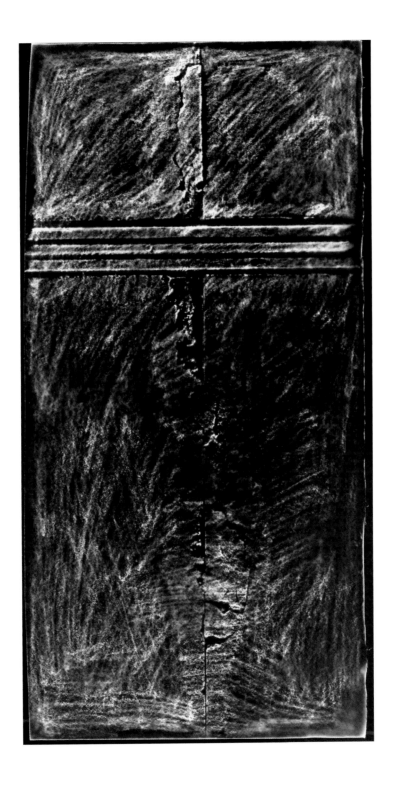

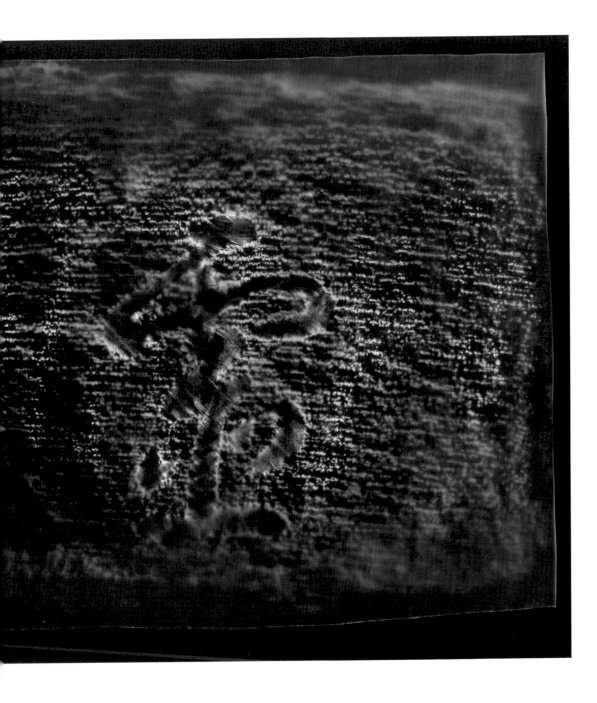

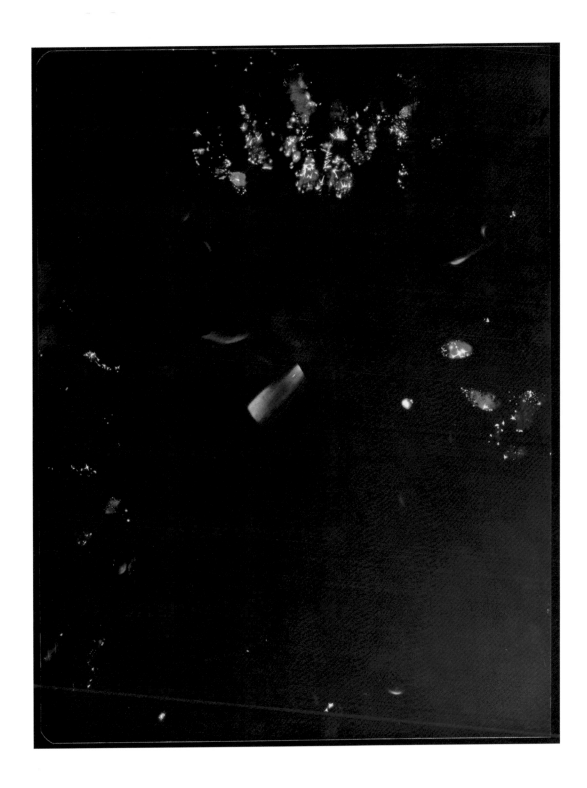

PLATE INDEX

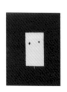
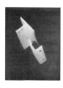
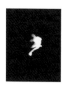
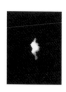
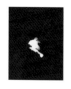

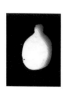

p 52:
Bottle I

瓶 I

24"x30"

p 53:
Bottle II

瓶 II

24"x30"

p 54:
Tiny Bottle

姫小瓶

8"x10"

p 55:
Little Bottle

小瓶

8"x10"

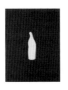

p 56:
Brown Bottle

茶色の瓶,

24"x30"

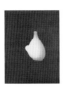

p 57:
Exploded Bottle

破裂した瓶

24"x30"

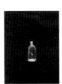

p 59:
Lone Blue Bottle
The liquid contents carbonized into a shiny
black chunk of matter.

孤の青い瓶
液体内容物は炭化してつやのある黒い塊となっ
ている。

23"x30"

p 61:
Groundskeeper Broom

庭仕事の箒

30"x72"

p 63:
Groundskeeper Shovel

庭仕事のシャベル

24"x60"

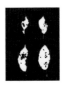

p 64:
Four Leaves

4枚の葉

8"x20"

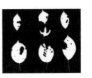

p 65:
Six Leaves

6枚の葉

8"x10"

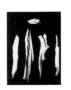

p 67:
Eucalyptus Bark

ユーカリの樹皮

24"x30"

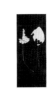

p 68:
Two Leaves

2枚の葉

8"x10"

p 69:
Leaf from a 2nd Generation A-Bombed Chinese
Parasol Tree

原爆二世の青桐の葉

16"x20"

p 71:
Dead Hiroshima Flowers
広島の枯れた花
24"x30"

p 72-73:
Eucalyptus Leaves
ユーカリの葉
24"x28"

p 74:
Dark Ladder
(American Orchard Ladder, not A-bombed.
There are no ladders in the Peace Memorial
Museum Archive.)
濃い色の梯子(アメリカの果樹園用梯子で、被爆は
していない。平和記念資料館の保管資料中に梯子
は存在しない。)
30"x72"

p 75:
Pale Ladder
(see caption for photograph on page 74)
薄い色の梯子(74ページの写真説明を参照)
30"x96"

*Silver Gelatin / Photographic Contact Prints from
Rubbings of A-bombed Surfaces in Hiroshima, 2008:*

銀–ゼラチン／コンタクトプリント 広島の被爆物
表面の拓本:

p 78-79:
Front and Back of a Leaf from a 2nd
Generation A-bombed Chinese Parasol Tree
被爆二世の青桐の葉の表面と裏面
24"x44"

p 81:
Fire Tree
燃える木
20"x26"

p 82:
Kurogane Holly Tree
クロガネモチ
17"x24"

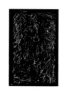

p 83:
Hackberry Tree
エノキ
20"x37"

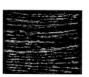

p 85:
Rope Around an A-Bombed Willow Tree
被爆した柳をめぐる綱
23"x18"

p 86:
Made In Japan
These bricks are in the basement of the old
Fuel Hall and City Planning Office, where Mr.
Nomura Eizo survived the A-bomb because he
went down to the basement to retrieve some
paperwork. The old Fuel Hall is now the Peace
Memorial Park Rest House, 2 blocks from the
hypocenter.

日本製
これらの煉瓦は旧広島県燃料配給統制組合の燃料
会館地下にあり、野村英三氏は、書類を取りにその
地下へ降りたために助かった。爆心地から通り2本
を隔てた旧燃料会館は、いまでは平和記念公園のレ
ストハウスとなっている。
20"x24"

p 87:
Keyholes
This door is in the basement of the old Fuel
Hall and City Planning Office (see caption for
photograph on page 86).

鍵穴
この扉は旧広島県燃料配給統制組合の燃料会館地
下にある(86ページの説明を参照)。
7"x14"

p 89:
Basement Door
This door is in the basement of the old Fuel Hall and City Planning Office (see caption for photograph on page 86).

地下室のドア
この扉は旧広島県燃料配給統制組合の燃料会館地下にあった（86ページ写真説明を参照）。

32"x45"

p 91:
Hypocenter Sidewalk
These valve covers are for cleaning, drainage, and for stopping water flow from branch waterways.

爆心地の歩道
二つの円形蓋はそれぞれ掃除口用と注水栓用のもの。

20"x24"

p 92-93:
Kokō-kyō Bridge, Shukkeien Garden
The bomb destroyed all the buildings in the garden, but this pedestrian bridge withstood the blast. Many survivors sought refuge in the garden after the A-bomb, but died before receiving medical care. Their remains were interred within the garden.

縮景園跨虹橋
原爆により縮景園の亭館すべてが消失したが、この橋は爆風に耐えた。大勢の被爆者がこの庭園に逃れたが、手当てを受ける前に亡くなった。遺骨は庭園内に埋葬された。

6ftx20ft

p 94:
Bank Floor I
This former Hiroshima branch of the Nippon Bank stands in the center of the city. Even though this bank was only 380 meters from the hypocenter, it withstood the blast. It was used as a bank until 1992. Now it is a cultural center for exhibitions where I held an exhibition of *After Hiroshima* in 2011.

銀行の床 I
この日本銀行旧広島支社は、市の中央に建っている。銀行は爆心地からわずか３８０ねーとるに位置していたが、被災に耐えた。1992年まで銀行として使用された。今では芸術文化活動拠点として利用されている（私はここで2011年に『ヒロシマ・そのあと』展を開いた）。

4ftx5ft

p 95:
Bank Floor II
The city has installed millions of paper cranes from all over the world on the top floor, along with a chronological installation on Sadako Sasaki, who was two when the bomb was dropped. She was diagnosed with leukemia at the age of ten and folded over 1,000 paper cranes to prove the legend that by doing so a sick person would be cured. She died in 1955.

銀行の床 II
広島市は世界中から寄せられた幾百万もの折り鶴を、被爆時に2歳であった佐々木禎子の年代順の展示とともに。最上階においている。10歳の時に白血病と診断され、千羽鶴を折ると病気が治るという言い伝えを信じて鶴を折り続け、その数は千羽を超えた。禎子は1955年に亡くなった。

6"x16"

p 97:
Bank Floor III
The city has left patches of the wood parquet floors, the old basement safes, and the original bank countertops exposed and has a permanent photographic display of the history of the building from before and after the bomb. Most exhibitions and cultural events are related to war and peace.

銀行の床III
広島市は、原爆以前以後からの寄せ木張りの床、古い地下室の金庫、もともとのカンタートップなどを多少残しており、原爆以前以後の建物の歴史を常設写真展示をしている。ここで開かれる展示や文化的催し物の多くは戦争と平和にかかわるものである。

12"x18"

p 99:
Bank Counter
Roland Barthes writes in the chapter "Center-City, Empty Center" in *Empire of Signs*, "In accord with the very movement of Western metaphysics, for which every center is the site of truth, the center of our cities is always FULL; a marked site, it is here that the values of civilization are gathered and condensed: spirituality (churches), power (offices), money (banks), merchandise (department stores), language (cafes and promenades): to go downtown or to the center-city is to encounter the social 'truth,' to participate in the proud plenitude of 'reality.' The city I am talking about offers this precious paradox: it does possess a center, but this center is empty."[1]

銀行のカウンター
ロラン・バルトは『表徴の帝国』(別訳では『記号の国』)のなかの「都市中心部、空虚なる中心」という章において次のように述べる。「西欧の形而上学の動きでは中心はいずれも真理の場所であって、我々の都心はいつも満ちみちている。それは特別な場所であり、そこでこそ文明の価値は集積し凝結する――精神面(教会)、権力(当局)、金銭(銀行)、商品(百貨店)、言語(喫茶店や散歩道)。町なか、あるいは都心に行くということは、社会的な「真理」に出会うこと、「現実」という誇るべき豊富さに参与することだ。ここで私のいう都会は、貴重なパラドックスを提示する。中心を持ってはいるが、この中心は空白である、というパラドックスだ。」

9"x16"

p 101:
Glass Shards Lodged in Wooden Bank Wall
(from the impact of the blast)

銀行の板壁に刺さったガラスの破片(爆風の衝撃によるもの)

5"x24"

p 102-103:
Comfort Souls, Ninoshima Island
This is taken from a large stone memorial to those who died on Ninoshima as a result of the A-bomb. During the war the island housed a fuel depot and training facilities and served as a quarantine center for the Imperial Japanese Army and Navy. A dock, arsenal, facilities for the study of infectious diseases contracted by service personnel overseas, an orphanage for war orphans (still in use today), a horse quarantine station, and crematorium were built on the island. Over 10,000 victims of the bombing were shipped to an emergency field hospital on Ninoshima. Thousands died on the island. The quarantine station operated until 1958, when it was converted into a school. In 1971, a mass grave containing 571 victims' skeletons was found on the grounds of the school. All the remains were transferred to the Atomic Bomb Memorial Mound in Peace Park. More remains were exhumed in 2004. These Japanese characters on memorials throughout Hiroshima, which translate as "comfort souls," comfort the souls not only of the dead but also of the living.

1 Roland Barthes, *Empire of Signs* (New York: Hill and Wang, 1983).

ロラン・バルト『表徴の帝国』英訳Hill and Wang, 1983年、和訳は新潮社、1974年。

慰霊、似島
原爆により似島で亡くなった人々のための慰霊碑より。戦争中、似島には燃料保存所と訓練施設があり、陸軍検疫所が置かれていた。船着き場、弾薬庫、帰還兵士が海外で感染した伝染病の研究施設、戦争孤児のための孤児院(第一検疫所跡で、児童養護施設似島学園として現在も運営)、馬匹検疫所と焼却炉、火葬場、などが島に建てられた。1万人以上の被爆者が似島に運ばれ、検疫所を臨時野戦病院としてその収容にあたった。何千人もがそこで亡くなった。検疫所は1958年まで機能し、跡地に学校が設置された。1971年にはその敷地内で571体の犠牲者の遺骨を含む共同墓地が発見された。すべての遺骨は広島に運ばれ, 平和記念公園の原爆供養塔に納骨された。2004年の発掘では、新たに遺骨が出土した。広島のどの慰霊碑にも彫られている「慰霊」という2字は、亡くなった人々の霊を慰める意味であるが、生きている人々の心をも慰めるという願いがこめられる。

23"x43"

p 105:
Lingering Radiation
An autoradiograph is a sheet of x-ray film that registers radioactive emissions from objects. In this case, a fragment of an A-bombed tree was placed on x-ray film in light-tight conditions for ten days. A photographic contact print of the exposed x-ray was then made in the darkroom.

残存放射能
オートラジオグラフ (放射線写真)はオブジェからの放射性放出を捉えたX線フィルムの一枚である。この作品では、被爆した木の断片を遮光状態のままX線フィルム上に十日間置いた。そのあと、露光したX線の密着写真を暗室で作成した。

11"x14"

p 114,117:
My Daughter Harper's Feet

娘ハーパーの両足

24"x30"

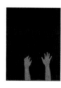

p 114,117:
My Son Guthrie's Hands

息子ガスリーの両手

24"x30"

SOURCES/出典

Adorno, Theodor W. "Cultural Criticism and Society," in *Prisms*, Translated by Shierry Weber Nicholsen and Samuel Weber. Boston: MIT Press, 1983. Originally published in German, 1949. テオドールW. アドルノ『プリズム――文化批判と社会』法政大学出版局、1970年／改題『プリズメン』筑摩書房、1996年。

Barthes, Roland. *Empire of Signs*. New York: Hill and Wang, 1982. ロラン・バルト『表徴の帝国』宗左近訳、新潮社、1974年、ちくま学芸文庫1996年。

Becquerel, Henri. "Sur les radiations émises par phosphorescence" [On the invisible rays emitted by phosphorescent bodies]. *Comptes Rendus* 122 (1896), translated by Carmen Giunta. (アンリ・ベクレル「蛍光体によって放たれる不可視の放射線について」)

Berger, John. *The Sense of Sight*. New York: Vintage International, 1985. (ジョーン・バージャー『視覚』)

Davis-Gardner, Angela. *Plum Wine*. New York: The Dial Press, 2007. (アンジェラ・デイヴィス゠ガードナー『梅酒』)

Del Tredici, Robert. *At Work in the Fields of the Bomb*. New York: Perennial, 1987. (ロバート・デル・トレディチ『核兵器分野での仕事』)

Deutsche, Rosalyn. *Hiroshima After Iraq: Three Studies in Art and War*. New York: Columbia University Press, 2010. (ロザリン・ドイチ『イラク後のヒロシマ――美術と戦争にかかわる三つの作品』)

Dower, John W. *Embracing Defeat: Japan in the Wake of World War II*. New York: W. W. Norton and Company, The New Press, 1999. ジョーン・ダワー『敗戦を抱きしめて』三浦陽一・高杉忠明訳、岩波書店、2001年。

Dower, John W., Adam Harrison Levy, David Monteyne, Erin Barnett (ed.), and Philomena Mariani (ed.) *Hiroshima Ground Zero 1945*. New York: International Center of Photography/Steidl, 2011. (ジョーン・ダワー他『広島爆心地1945年』)

Duras, Marguerite. *Hiroshima mon amour* (screenplay), trans. Richard Seaver. New York: Grove Press, 1961. マルグリット・デュラス、ジェラール・ジャルロ『ヒロシマ、私の恋人　かくも長き不在』清岡卓行訳、坂上脩訳、筑摩書房、1970年。『ヒロシマ　私の恋人』清岡卓行訳、ちくま文庫、1990年。

Gowin, Emmet. *Changing the Earth*. New Haven: Yale University Art Gallery, 2002. (エメット・ゴウィン『地球を変える』)

The Greens / European Free Alliance in the European Parliament and the International Coalition to Ban Uranium Weapons. *The Human Cost of Uranium Weapons*. 2007. (緑の党／ヨーロッパ議会内ヨーロッパ自由連盟およびウラン兵器禁止を求める国際連合『ウラン兵器の人的被害』)

Hersey, John. *Hiroshima*. New York: Alfred. A. Knopf, 1946. ジョン・ハーシー『ヒロシマ／Hiroshima』石川欣一・谷本清共訳、法政大學出版局、1949年。

Hiroshima Peace Memorial Museum. *The Spirit of Hiroshima*. 広島平和記念資料館『ヒロシマを世界に：図録』1999; *A-Bomb Drawings by Survivors*, 『図録原爆の絵――ヒロシマを伝える』2007.

Kokusai, Kōryū Kikin and Iwanami Eiga Seisakujo. *Hiroshima and Nagasaki: The Harvest of Nuclear War* (documentary film). Tokyo: Iwanami Productions, Japan Foundation, 1982. 岩波映画製作所、製作陣内直行、脚本・監督早川正美、撮影八幡洋一『ヒロシマナガサキ　核戦争のもたらすもの』1982年。

Light, Michael. *100 Suns*. New York: Alfred A. Knopf, 2003. (マイケル・ライト『100個の太陽』)

Lindqvist, Sven. *A History of Bombing*. London: Granta, 2001.（スヴェン・リンドクヴィスト『爆撃の歴史』)

Lippit, Akira Mizuta. *Atomic Light (Shadow Optics)*. Minneapolis and London: University of Minnesota Press, 2005. (リピット水田尭『原子の光（影の光学）』)

Maclear, Kyo. *Beclouded Visions: Hiroshima-Nagasaki and the Art of Witness*. New York: State University of New York Press, 1999. (キョー・マックリア『曇った視力−−ヒロシマ・ナガサキと目撃者の絵画』)

Miyako, Ishiuchi. *Hiroshima*. Tokyo: Shueisha Inc., 2008. 石内都『ひろしま』集英社、2008年。

Mizuno Jun'ichi. *Symphonic Poems: Hiroshima*. Tokyo: Marunouchi Publishing Company, 1999. 水野潤一『交響詩集　ヒロシマ』丸の内出版、1999年。

Ogasawara, Motoo. *Hiroshima: Mothers' Prayers* (documentary film). Hiroshima: Hiroshima Peace Memorial Museum, 1990. 小笠原基生『ヒロシマ・母たちの祈り』(原爆記録映画)日本映画新社製作1990年。

Ogura, Toyofumi. *Letters from the End of the World: A Firsthand Account of the Bombing of Hiroshima*. Tokyo: Kodansha International, 1997. 小倉豊文『絶後の記録　広島原子爆弾の手記』太平出版社、1971年、のち中公文庫『ヒロシマ−−絶後の記録』日本ブックエース　平和文庫。英訳は

Resnais, Alain. *Hiroshima mon amour*, film, 1959. アラン・レネ監督映画『二十四時間の情事』1959年。

Sebald, W. G. *On the Natural History of Destruction*. New York: Modern Library, 2004. W. G. ゼーバルト『空襲と文学』鈴木仁子訳、白水社、2008年。

Slavick, elin o'Hara. *Bomb After Bomb: A Violent Cartography*. Milan: Charta, 2007. (エリン・オハラ・スラヴィック『爆弾また爆弾−−暴力的な地図作り』)

−−−. "Hiroshima: After Aftermath," *Critical Asian Studies* 41, no. 2 (2009): 307-328. (同「ヒロシマ−−−被害のあとのあと」)

−−−. "Hiroshima: A Visual Record," *The Asia-Pacific Journal* 30-3-09 (2009). (同「ヒロシマ−−−ある視覚的記録」)

−−−. "Memorials in the After Aftermath: Hiroshima and France," *Public Art/Culture/Ideas* 42 (*Traces*) (2011): 93-100. (同「被害のあとのあと−−−ヒロシマとフランス」)

−−−. "Empathetic Vision: Aesthetics of Power and Loss," in *Virilio Now: Current Perspectives in Virilio Studies*, ed. John Armitage, 115-144. Cambridge, UK: Polity Press, 2011. (同「感情移入のヴィジョン−−−力と喪失の美学」)

Slavick, Susanne. *Out of Rubble*. Milan: Charta, 2011. (スザーン・スラヴィック『廃虚から』)

Shamsie, Kamila. *Burnt Shadows*. New York: Picador, 2009.（カミラ・シャムジー『燃えた影』)

Sontag, Susan. *Regarding the Pain of Others*. New York: Farrar, Straus and Giroux, 2003.スーザン・ソンタグ『他者の苦痛へのまなざし』北条文緒訳、みすず書房、2009年。

−−−. *On Photography*. New York: Farrar, Straus and Giroux, 1973. 同『写真論』近藤耕人訳、1979年。

Tanaka, Yuki and Marilyn B. Young. *Bombing Civilians: A Twentieth-Century History*. New York/London: The New Press, 2009. (田中利幸・マリリンB. ヤング共著『民間人への爆撃−−−20世紀の歴史』)

Tsuchida, Hiromi. *Hiroshima Collection*. Japan: NHK, 1995; 土田ヒロミ『ヒロシマ・コレクション−−−広島平和記念資料館蔵』日本放送出版協会、1995年。

−−−. *Hiroshima Monument II*. Toyko: Tosei-Sha, 1995.『ヒロシマ・モニュメント』冬青社、1995年。

Virilio, Paul. *Art and Fear*. London and New York: Continuum, 2003. (ポール・ヴィリリオ『芸術と恐怖』)

−−−. *Unknown Quantity*. New York: Thames and Hudson, 2003.(同『知られざる量』)

−−−. *Art as Far as the Eye Can See*. Oxford and New York: Berg, 2007. (同『目の及ぶ限りの芸術』)

Yamahata, Yosuke. *Nagasaki Journey: The Photographs of Yosuke Yamahata, August 10, 1945*. San Francisco: Pomegranate Artbooks, 1995. 山端庸介、NHK取材班『長崎よみがえる原爆写真』日本放送出版協会、1995年。

Yoneyama, Lisa. *Hiroshima Traces: Time, Space and the Dialectics of Memory*. Berkeley: University of California Press, 1999. (リサ・ヨネヤマ『ヒロシマの痕跡−−−時間、空間、および記憶の弁証法』)

Zinn, Howard. *A People's History of the United States*. New York: HarperCollins, 1980. ハワード・ジン『民衆のアメリカ史』富田虎男訳、ティービーエスブリタニカ、1993年。世界歴史叢書、2005年。

−−−. *Hiroshima: Breaking the Silence*. Westfield, New Jersey: Open Magazine Pamphlet Series, 1982. (同『沈黙を破る』)

−−−. *Artists in Times of War*. New York: Seven Stories Press, 2003. (同『戦時の芸術家たち』)

−−−. *Just War*. Milan and New York: Charta, 2006. (同『聖戦』)

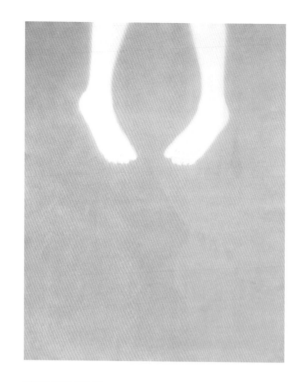

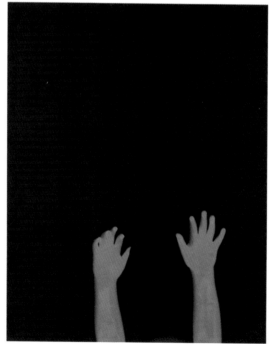

ACKNOWLEDGEMENTS

This work is made possible by the generous support of the people of Hiroshima. These include directors, associates, and curators at the Hiroshima Peace Memorial Museum, Peace Culture Foundation, Center for Nonviolence and Peace, City Culture Foundation, World Friendship Center, and Peace Institute, as well as the Museum of Contemporary Art. Special thanks to comrade Steven Leeper, chairman of the Hiroshima Peace Cultural Foundation, for allowing me to work in the Peace Memorial Museum with the help of Miwako Sawada, Mari Shimomura, and Kahori Wada. Michiko Yamane gave me tours of Hiroshima, helped install my exhibit in the A-bombed bank, transported and translated for me when I needed it, gave me the opening poem for this book, and continues to inspire me. Kiriko Miyamoto became my friend in Hiroshima and helped me in so many ways. Larry and JoAnn Sims of the World Friendship Center provided a home away from home and so much more.

I would also like to thank Yukie Kamiya, Hiroshi Sunairi, Lindsey Britt, Deanna Brown, Gail Goers, Gayle Sato, Joel Sternfeld, Ian Saville, Lily Saville, my sister Madeleine Marie Slavick for two unforgettable visits to Hiroshima and her editorial help, my sister Susanne Slavick for including this work in the traveling exhibition and book *Out of Rubble*, Kazuma Suzuki, Bo Jacobs, Sasha Alexandra Omukova and the people at the International YMCA in Hiroshima, Yuko Nakashima, Eric Grant at RERF, Chef Tomo, Hiroko Takahashi at the Hiroshima Peace Institute for her research and spirit, Yasuko Okane, Yoko Ono, Kyo Maclear, Janice McCullom, *hibakusha* (A-bomb survivor) Emiko Okada, Ishiuchi Miyako, Emi Yamanaka, Lisa Ross, Laura Guinan, Lauren Adams, Amy White, Tama Hochbaum, Kevin Hewison, Stephanie Nelson, Claude Baillargeon, Sylvia Watanabe, John Armitage, Della Pollock and the *Journal of Cultural Studies*, Jeffrey St. Clair at *CounterPunch*, Thomas Fenton and *Critical Asian Studies*, Mark Selden and the *Asia-Pacific Journal*, Bob Del Tredici and my comrades in the Atomic Photographers Guild, Alice Stewart, Gayle Greene, Yoshi Okomoto, Yuki Tanaka, Doumen Masakazu, Atsuko Sakaki, Joseph Gerson, Hiromi Tsuchida and my mother for giving me his book of photographs, Lindsay Fulenwider, Abigail Brooks, Jim Hirschfield, Chris Ciccione, Cathy Lutz, John Berger, Noam Chomsky, and Howard Zinn. I thank everyone who helped translate the title of this book: Gayle Sato and Yukiko Terazawa, Steve Leeper, Yuko Takahashi, and Kyoko Selden. Extra special thanks to Kyoko Selden for her expert translation of this book. Thanks to Amy Ruth Buchanan for her generous design advice. The University Research Council at the University of North Carolina, Chapel Hill supported this project.

Jim Elkins is one of those professors who teaches and challenges you well after you have finished studying with him. It is an honor to have his ridiculously brilliant voice in this book. And for this I must thank my dearest friend, Carol Mavor, for suggesting him. Carol contributed a beautiful essay to my last book that compelled me to make the cyanotypes in *this* book and continues to look at the world with me. Thank you, Jim and Carol.

Taj Forer and Michael Itkoff at Daylight Books are two of the most engaged, committed, dedicated, and brilliant editors and photographers one could hope for. Ursula Damm designed my dream book.

None of this would be possible without the solidarity and inspiration of my true comrade, David Richardson, with whom I am trying to raise two pacifist children, Guthrie and Harper Ursula. It is his brilliant epidemiological work that brought us to Hiroshima, and it is his love that sustains me.

謝辞

本書は広島の皆様の寛大な御支持により可能となりました。広島平和記念資料館、広島平和文化センター、非暴力平和研究所、ワールドフレンドシップセンター、広島平和研究所、および現代美術館の所長・館員・学芸員の皆様のお世話になりました。とくに広島平和文化センター理事長スティーヴン・リーパー同志の御協力により、澤田美和子、下村真理、和田香穂里のお三方の手助けを得て平和記念資料館で仕事させていただけたことに感謝します。山根美知子さんは広島を案内し、被爆した銀行での私の展示の据付けを手伝い、必要があればいつでも移動の便をはかり通訳の労を取られたほか、本の冒頭に掲げた詩も彼女の提供によるもので、今なおお刺激を受けています。宮本きり子さんは広島での私のよき友となり、多くの面でお力添えをくださいました。ワールドフレンドシップセンターのラリーおよびジョウアン・シムズ御夫妻からは広島滞在中、温かく迎え入れていただき、あまたの恩恵に浴しました。

ほかにも次の方々にお礼を申し上げたいと思います。神谷ゆきえ、砂入博史、リンジー・ブリット、ディアナ・ブラウン、ゲイル・ゴアズ、ゲイル・サトー、ジョエル・スターンフェルド、イーアン・サヴィル、二度の忘れ得ぬ広島訪問をはたし、校正の手伝いをした姉のマドレン・マリー・スラヴィック、巡回展示会『瓦礫より』とその本にこの仕事を含めてくれた姉のスザーン・スラヴィック、鈴木和満、ボウ・ジェイコブズ, サシャ・アレクサンドラ・オムコヴァと広島国際YMCAの人々、中島佑子、RERFのエリック・グラント、シェフのトモ、その研究と気迫に触れさせていただいた広島平和研究所高橋博之、大兼保子、ヨーコ・オノ、キョー・マックリア、ジャニス・マッカロム、岡田恵美子（被爆者）、石内都、山中えみ、リサ・ロス、ローラ・ギナン、ローレン・アダムズ、ケヴィン・ヒュイソン、ステファニー・ネルソン、クロード・バヤルジョン、エイミー・ホワイト、タマ・ホッホバウム、シルヴィア・ワタナベ、ジョーン・アーミテッジ、デラ・ポロックと『文化研究誌』、『カウンターパンチ』のジェフリー・セントクレア、トマス・フェントンと『批判的アジア研究』、マーク・セルデンと『アジア太平洋誌ジャパンフォーカス』、

ボブ・デル・トレディチと原爆写真家ギルドの同志、アリス・スチューワート、ゲイル・グリーン、ヨシエ・オカモト、田中利幸、榊敦子、道面雅量、土田ヒロミと彼の写真集を授けてくれた私の母、リンゼー・フレンワイダー、アビゲイル・ブルックッス、ジム・ハーシフィールド、クリス・チチオーネ、キャシー・ルッツ、ジョーン・バージャー、ノーム・チョムスキー、およびハワード・ジンの皆様です。また、本の題名を和訳する面で知恵をお貸しいただいたゲイル・サトーと寺沢ゆきこ、スティーヴ・リーパー、高橋ゆうこ、セルデン恭子に感謝します。この本の訳者セルデン恭子にはとくに感謝します。エイミー・ルース・ブキャナンからはデザインについて惜しみなき助言をいただき、お礼を申します。ノース・キャロライナ州立大学チャペル・ヒル校の大学研究審議会からはこの企画の支持を得ました。

学生の師事期間が終わってからもあとあとまで教えを垂れ、意欲をかき立てる教授方がおられますが、ジム・エルキンズもそのようなお一人です。この本の中に、その途方もなく明敏な考察を含めることことができて光栄に思います。彼に紹介文を依頼することを提言したキャロル・メイヴァーに感謝します。キャロルは、私の前の本に美しいエッセーを寄せましたが、そこから今度の本の青写真制作をせざるを得ない成行きとなり、今でも一緒に世界を見ることを続けています。ジム、キャロル、ありがとうございます。

デイライト・ブックスのタージ・フォーラーとマイケル・イトコフは、願ってもないほどすぐれて熱心な、責任感の強い明晰な編集者兼写真家です。ウルスラ・ダムは私の夢の本を装丁しました。

二人の子ども達、ガスリーとハーパー・ウルスラを平和主義者へと共に育てているデイヴィッド・リチャードソンは私の真の同志であり、その連帯と励ましなくしては、以上はすべて不可能だったはずです。私たちが広島に行ったのも彼のめざましい疫病学研究のおかげであり、私をつねに元気づけてくれるのも彼の愛情にほかなりません。

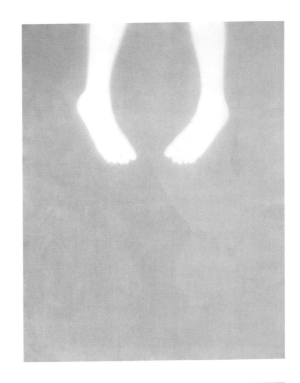

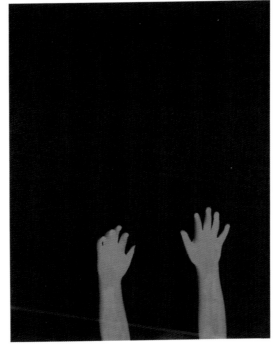

TRANSLATOR'S NOTE

While attempting to translate elin o'Hara slavick's beautiful essay as well as James Elkins's "ridiculously brilliant" introduction, I was made to think of light, shadow, reflection, projection, form, memory, flash, exposure, radiation, and development. In elin's writing, light and shadow seem to merge into an artistic sphere of forms emerging from light and shadow of the past and of memories arrested in re-enacted photographic images. The intricate conceptual and linguistic play passing between light and shadow was challenging but not impossible to render into Japanese. The Japanese word *kage*, to begin with, means light, shadow, or form, though it normally means "shadow" or "shade." The word sometimes means "light" as in a compound word *tsukigake*, moonlight, and at other times "form" as in another expression *hitokage*, a human presence detected from some distance. The word *kage*, in other words, means that which projects, and that which is projected. More difficult to handle were photographic terms like exposure and development, which carry multiple meanings, and of course the keyword photography, recording by light. The Japanese word for photography, *shashin*, simply means "copying the truth," or faithful-to-life reproduction, which contains no reference to light. I sensed verbal awareness of photography as connected to light and exposure everywhere in elin's essay. It was a pleasurable learning experience to try to reflect as much of those things as possible in the translation. In doing so, I saw elin's photography as the art of speaking through light and shadow about what humans can do to and for other humans and things.

Kyoko Selden

訳者あとがき

エリン・オハラ・スラヴィックの鮮やかなエッセーとジェイムズ・エルキンズの「途方もなく明敏」な考察を和訳するに当たり、光、影、映像、投影、形、記憶、閃光、露光、放射、現像などについて考えさせられました。エリン・スラヴィックの書き物の中で、光と影とは、過去の光と影の中から浮かび上がる形象と写真的記憶として捉えられ再演される記憶とを合わせた、芸術的一領分へと同化してゆくように見えました。光と影の間を渡る複雑な観念的言語的動きを日本語でとらえるのは易しくはないとしても、不可能ではありませんでした。そもそも「影」という日本語は、普通は影を意味しますが、時には光を指し、また姿をも指します。月影とは月光のことですし、人影といえば、少し遠くから認められる人間の姿です。言い換えれば、「影」とは投影されたものだけでなく、投影する本体をも意味します。それより難しいのは、露出とか現像とかいった用語の扱いで、これらもまた多義的に使われ得ます。また、肝心の「フォトグラフィー」という言葉ですが、これは文字通りに言えば光による記録法です。ところが日本語の「写真」は真を写す、ものをそっくりそのままに撮るというだけで、光の意味が入っていません。エッセー中には、光と照射につながるものとしての「フォトグラフィー」という言語意識が感じられました。これらのことどもをできるだけ訳文に反映させようと努めることは楽しく、学ぶことの多い作業でした。それを試みながら、彼女の写真術は、人間が人間や物体にたいして何をしてしまうか、そして何をすることができるかについて、光と影を通して語る営みであるように感じました。

セルデン恭子

CONTRIBUTORS

elin o'Hara slavick is a Professor of Visual Art, Theory, and Practice at the University of North Carolina at Chapel Hill. She received her MFA in Photography from the School of the Art Institute of Chicago and her BA from Sarah Lawrence College. Slavick has exhibited her work internationally and is the author of *Bomb After Bomb: A Violent Cartography*, with a foreword by Howard Zinn. She is also a curator, critic, and activist.

エリン・オハラ・スラヴィックは、ノースカロライナ州立大学チャペルヒル校の視覚芸術・理論・実践の教授。シカゴ美術館附属美術大学で写真学芸術修士を取得、学士号はセアラ・ローレンス大学で取得。国際的に作品を展示。ハワード・ジンによる序文掲載の『爆弾また爆弾――暴力的な地図作り』の著者。キューレイター、評論家、活動家でもある。

James Elkins's writing focuses on the history and theory of images in art, science, and nature. His books include: *What Painting Is*; *On Pictures and the Words That Fail Them*; *The Object Stares Back: On the Nature of Seeing*; *Art Critiques: A Guide*; and *What Photography Is*, written against Roland Barthes's *Camera Lucida*. He is E.C. Chadbourne Chair in the Department of Art History, Theory, and Criticism at the School of the Art Institute of Chicago.

ジェイムズ・エルキンズの著作は美術・科学・自然におけるイメージの歴史と理論を中心とする。主著に『絵画とは何か』『うまくゆかない絵画と言葉について』『オブジェは見つめ返す――見ることの本質について』『芸術批評――手引き』およびロラン・バルト著『明るい部屋』に対して書かれた『写真とは何か』がある。シカゴ美術館付属美術大学で美術史・理論・批評学科E. C. チャドボーン教授。

Kyoko Selden is coeditor of *More Stories by Japanese Women Writers: An Anthology* that is the sequel to *Japanese Women Writers: Twentieth Century Short Fiction*. Her other translations include Kayano Shigeru's *Our Land Was a Forest*, *The Atomic Bomb: Voices from Hiroshima and Nagasaki*, Honda Katsuichi's *Harukor: An Ainu Woman's Tale*, and Cho Kyo's *The Search for the Beautiful Woman: A Cultural History of Japanese and Chinese Beauties*. She taught Japanese at Cornell University until her retirement.

セルデン恭子は『日本女性作家作品集』および続編の共編共訳者。ほかの主な訳本に萱野茂『アイヌの碑』、作品集『広島と長崎の声』、本多勝一『アイヌ民族』、張競『美女とは何か――日中美人の文化史』がある。元コーネル大学アジア研究学科日本語プログラム教師。

Mizuno Jun'ichi is a Kobe-born author and advocate of what he calls Pax Turistica (peace through tourism). The family moved to Hiroshima in the fall of 1944. He was fourteen when he was exposed to radiation and lost his parents and all three younger siblings to the bomb. After a long search he located his mother. She died on September 14, 1945. According to a prose poem he wrote, she died while he was away briefly. Upon his return to Hiroshima, a friend took him to the river bank. In a little hollow under a tin plate were bones. He picked a few and put them in a brown envelope, and his friend wrapped it in white cloth. "Do Walk Quietly" is the final poem in his *Symphonic Poems: Hiroshima*, a verbal symphony in four movements.

水野潤一『交響詩集　ヒロシマ』東京、丸の内出版1999年。水野潤一(1931–)は神戸生まれ、本を書き、旅をし、PAX TURISTICA(観光による平和)の提唱者。子供のころから音楽を愛し、トランペットとハーモニカを楽しんだ。父の転勤によって1944年秋、広島に移住。1945年春、広島第二中学から大阪陸軍幼年学校に進学。原爆で両親と妹弟3人をすべて失う。終戦直後広島に帰り、14歳で自身も被爆する。探しまわった末、母親を見つけるが、母は9月14日、彼がわずか出かけている間に亡くなる。散文詩「あなたは居なくなっただけだ」によれば、少年は見知らぬ女につれられて、河辺の土手に上った。トタン板の下の小さい凹みに幾本もの骨があった。何本かの骨を拾って茶色の封筒に入れると、見知らぬそのひとは白い布でそれを包んだ。「静かに歩いてつかあさい」は4楽章からなる『交響詩集』の最終詩。